MAGIC REALIST LANDSCAPE PAINTING

MAGIC REALIST
LANDSCAPE PAINTING

BY RUDY DE REYNA

WATSON-GUPTILL PUBLICATIONS/NEW YORK

PITMAN PUBLISHING/LONDON

For Katherine

Copyright © 1976 by Watson-Guptill Publications

First published 1976 in the United States and Canada by Watson-Guptill Publications
a division of Billboard Publications, Inc.
1515 Broadway, New York, N.Y. 10036

Published in Great Britain by Pitman Publishing, Ltd.
39 Parker Street, London WC2B 5PB
ISBN 0-273-00121-3

Library of Congress Cataloging in Publication Data
De Reyna, Rudy, 1914-
 Magic realist landscape painting.
 Bibliography: p
 Includes index.
 1. Landscape painting—Technique. 2. Magic
realism (Art) I. Title.
ND1342.D47 1976 758′.1 76-2720
ISBN 0-8230-2955-7

Manufactured in U.S.A.

First Printing, 1976
Second Printing, 1976
Third Printing, 1977
Fourth Printing, 1977

ACKNOWLEDGMENTS

I should like to express my most grateful thanks to Watson-Guptill Publications for letting me communicate with thousands of students and artists. And since a book is the joint effort of author, editor, and book designer, I extend my gratitude to Ellen Zeifer for clarifying my words, and to Bob Fillie for putting my pictures in order.

Rudy de Reyna
E. Sandwich, Mass.

CONTENTS

INTRODUCTION

With no meanderings into philosophical or metaphysical pishposh I must admit that to qualify the word "magic" as it pertains to the content and purpose of this work is no easy task. I could, of course, just ignore it and let you draw your own conclusions, but I can't because as a teacher I feel it my duty to explain everything. If magic—even as an adjective—didn't smack of spells and charms and rituals and other things that "go bump in the night," I could easily leave it alone. Am I making too much fuss about something I know you understand to mean nothing more than consummate craftsmanship? All right. But what about "realism"? Well, it may mean different things to the scientist, the theologian, or the philosopher, but to the artist, realism means only one thing—the accurate and faithful transposing of the visual world to canvas or paper, stamped with the artist's individual soul. Mind you, I say transpose and not transcibe. As Somerset Maugham said, "It was never the artist's business to copy life." He was referring to the art of writing, but the quote also applies to the art of painting. As segments of life aren't given to an author neatly bound between two covers, so nature is not given to us perfectly arranged within a frame. With practice and determination anyone can learn to render things as they are, but to take these things and arrange them into a stirring pictorial statement takes the vision of an artist.

Realism, then, as it affects the natural things as we see them, becomes the antipode to magic and thus brings us back to earth and to the fact that only through keen observation and rigorous training can we hope to re-create the marvels of nature on a painting surface. For a painter to reach this lofty goal, he must expand his soul, sharpen his eye, and discipline his hand—three requisites that "maketh the full artist." Before the ladies take umbrage, let me say that I use the masculine only as a figure of speech; I'm well aware of my sisters of the brush who have scaled dizzying heights I shouldn't even attempt to climb. But I mustn't digress. The point is that you must paint and sketch and paint again, because it's the only way to develop your skill. To feel, to see, to paint—in that order—are the words that should be graven in your mind. "Hold the mirror up to nature," yes, but also be aware of the fact that the mirror cannot possibly be any larger than your soul. Let there be, then, the profoundest response and the deepest empathy between you and the objects you paint.

Remember that forbidding and unattainable as nature may seem at first, she eventually smiles upon those of us who try to paint her portrait. I know. I still have the first sketch I attempted in her presence—forty-odd years ago. I've kept it all this time as a constant reminder that I was a rank beginner once and that I'm still a student today, because one lifetime is not enough to learn all about painting.

Most people look but they do not see; so I learn to observe and to scrutinize the wonders of creation. As soon as you learn to do this, you'll be on your way to the mastery of the art that will enable you to accomplish your own magic realism.

Give me your eagerness to learn and I'll show you that creating a realistic painting is not at all difficult. But first, I must have, I repeat, your enthusiastic participation—nothing worthwhile was ever accomplished with half a heart. As there can be no donor without a recipient, there can be no teacher without a student—there

will be no joy in my sharing my knowledge with you if you're just going to glance at my book and return it to the shelf. I can think of no greater compliment than if when you're through with my book it has become dog-eared, paint-stained, and marked throughout with notations of your own. I shall try to deserve these marks of honor in every one of my following demonstrations.

There are countless approaches to painting. I'll concentrate here first on sketching from nature and then applying the garnered information to paintings done in the studio. To my mind this is one of the most exciting ways to work because it brings into play both the stimulation of direct contact with the source and the contribution the artist makes later in arranging and composing his painting. After I bring home a sketch or a study still throbbing with the life and the spirit I've caught from the real, I try to transplant that pulsating vigor to the work in the studio through the sustained effort of days and sometimes even weeks.

I use many of the black and white demonstrations of elements of the landscape in this book as references for the more detailed color demonstrations of paintings. You'll see that there's no mystery about it; it's only a matter of following the proper procedures. First there's a sketch, or sketches, done directly from life. They provide information on details, and more important, on the moods and effects that impelled me to record them as possible material for future paintings. As a builder attends first to the foundation of a house before he gives any thought to the roof, so should the painter look from the foundation of his painting—the conception—to the necessary steps leading to its completion. The sketches are of the subjects I respond to, and it's possible that you'll find them exciting too. Even if you don't, copy them anyway to learn the procedures and techniques that you can then apply to subjects of your own choice.

I do all the sketching demonstrations in five steps, but I execute them in as many different ways as *the subjects themselves require*. Obviously one cannot begin with a pencil drawing when sketching a storm, even if it's the practical way to begin when sketching a stone wall. I'll show you the proper manipulation of the tools required to pluck nature's fascinating detail, not just with brushes but with other unorthodox equipment better suited to the task.

When I do use brushes in these demonstrations, though, I usually use pointed sable watercolor brushes by Winsor & Newton or Grumbacher. To avoid repetition, I'll refer to these brushes by number only, without mentioning over and over again that they are pointed sable watercolor brushes. And whenever I use another kind of brush, I'll describe it. Please note that when I work directly from nature, I empty and shape the brushes on the margin of the pad; but when I work in the studio, I tape scrap paper on the edge of the drawing table for the same purpose. I must also mention that I find the Paper King pads that I use so often not at an artists' supplies shop but at a pharmacy! Always be on the alert for bargains like these when you shop for your materials.

Because I love classic restraint in color, I do most of my sketches in umber and black, adding a blue or yellow now and then. Try this monochromatic approach—you'll notice how little of the primaries you need to render a realistic painting.

I must mention that the majority of the sketches reproduced in this book were done from my car, which I've turned virtually into a traveling studio. I urge you to try drawing from your car because I'm confident that if you do so, you'll seldom tramp through the woods again burdened with all your sketching materials, and you'll have them on hand whenever you need them.

Just one more thing and I'll be done. In case you're wondering how it was possible to photograph every sequence of the steps, even under the most unfavorable weather conditions, the answer is very simple. The sketches were done twice—once in the field with written notations on the margin of the paper, and then again in the studio, where each step was photographed as it was done.

MATERIALS AND EQUIPMENT

As you probably know, whole books have been devoted to each of the media I discuss. The only purpose in describing them in a few words is to make you aware of them and perhaps introduce you to a new one or two. I've used all these paints—oil, acrylic, watercolor, opaque watercolor, and egg tempera—as well as pencil and India ink in my demonstrations. As I'm a firm believer that an artist should be conversant with several media so that he can use the one most suitable to a particular problem, I'd like you to investigate them all. As you practice and get acquainted with the different materials and equipment, you'll find that each one has different properties peculiar to itself. Should some materials prove troublesome, go ahead and meet their challenge, if only to extricate yourself from a cozy and comfortable rut—a deadly situation for any artist.

Oil

In my opinion, oil color is the most sensuous and the easiest to manipulate of all the media. It has drawbacks of course, but it also has undeniable virtues. I think that oil color's greatest attraction is that it blends so easily from one tone into another since it dries so slowly—although personally, I don't like to have to wait for paint to dry before I can continue. Oil is a marvelous medium when painting alla prima—painting an entire composition in one sitting—but if you underpaint, glaze, and scumble when striving for the meticulous detail of realistic rendering, oils can be frustrating.

You'll usually need bristle brushes for this medium, plus pointed sables for fine details. The painting knife comes in handy with the impasto passages, and you can also use it to smooth out extra paint left by the brush.

The thinning vehicles most widely used for oils are the prepared mediums bottled by manufacturers. These are usually mixtures of oil and turpentine with a spot of varnish. They do no harm, but my own preference for a thinning agent has always been plain turpentine because there's already enough oil in the pigment itself, and I'd rather varnish a painting after it's finished.

My palette in oils is as simple as in the other media—white, alizarin crimson, red, yellow ochre, and ultramarine blue. If you require other colors, go ahead and use them.

I usually paint on canvas with oils, and I work with a paper palette instead of the butcher's tray I use for the water-based media. Also, I absolutely couldn't do without a mahlstick to lean on.

Acrylic

Acrylic paint is the contribution of today's modern technology to the plastic arts. Many artists of my acquaintance have discarded their former media and use nothing but acrylic polymer colors which are permanent, water-soluble, quick-drying, and easy to manipulate whether they're used as the thinnest wash or the thickest

impasto. There's almost no effect that can be achieved with other paints that acrylic can't do also. If it were not for the fact that I love the challenge of egg tempera, the ease and tractability of opaque watercolor, and the spontaneity of transparent watercolor, I too would succumb to its charms. I love to use acrylic sometimes, but not exclusively.

Use bristle and sable brushes as I do with acrylic, or try the nylon brushes especially made for this medium. But remember, no matter what type of brushes you use, you must wash them *constantly*—never allow acrylic to dry on brushes or on painting knives. To thin acrylic, use water.

My palette in acrylic consists mainly of naphthol crimson, yellow ochre, ultramarine blue, and white. There are times when I have to dip into a bright yellow or a bright green, but as a rule those four colors are sufficient.

The supports when you paint with acrylic can range from watercolor paper to canvas. Further, tools besides brushes can be used to apply paint to the support, such as sponges or razor blades. Also try the matte and gloss mediums made specifically for acrylics—they give the pigment matte and gloss finishes.

Watercolor

The fluidity and luminosity of transparent watercolor are its main attractions for me. Certain things and effects in nature, such as Demonstration 16 in this book, cry out to be done in no other medium. As a rule I don't sketch with watercolor in the field because of its rigorous demands, but there are times when one must take the chance. The Pelikan color cakes (in the tin box) can be used either as transparent or opaque watercolor, depending on how much you dilute them, but I prefer the Symphonic sets by Grumbacher or the Winsor & Newton colors in tubes when tackling a true aquarelle where not even a whisper of white would be tolerated in the picture. It's valid, of course, to introduce opaque white into an aquarelle, but this is anathema to purists like me. As far as I'm concerned, if you use any opaque pigments, the result is not an aquarelle but a gouache.

The traditional brushes for this medium are the pointed red sable watercolor brushes, but don't exclude the flat sables and even bristle brushes when the occasion demands them. Many other tools can be used—from razor blades, paper towels, and sponges to dental tools and erasers, not to mention your own fingers.

As you probably know, the strength of the tone in watercolor depends on the amount of water added to the pigment. The more water, the lighter the tone, and vice versa.

My palette, as usual, consists of red, yellow, and blue, with dips into the umbers and black.

Although you can use many kinds of surfaces for watercolor, it's wisest to use watercolor paper such as the ones made by Arches and Fabriano for the best results. However, I often use illustration board or the Morilla pads. Experiment with many kinds of paper until you find your own favorites.

Opaque Watercolor

Opaque watercolor, as the name implies, is both opaque and water-soluble. Its greatest advantage is that you can begin to paint the middle values and then superimpose the lights and darks on top—unlike transparent watercolor where the whites must be the untouched paper itself. In addition to its capacity to cover a dark tone with a light one, opaque watercolor is also fast-drying; you can make changes and corrections without marring the freshness and directness of the original execution. Opaque watercolor is my favorite sketching medium—the Pelikan color box plus a jar of Rich Art white are constantly in the trunk of my car.

I also use Gamma grays, a set of grays numbered from 1 to 5 plus black and

white. No. 1 is the lightest; No. 5 is the darkest. They are indispensable to me for the many sketches where I work primarily in gray. One of the reasons I've always liked working in opaque grays is that as I look at the slant-and-well palette, I can easily match the value in the wells to the tone of the element I want to paint, realizing of course that each tone of wet pigment has a tendency to dry darker. Only practice will enable you to judge correctly which gray to choose for the tone you need on the picture. Also, you must dilute these grays—artists unacquainted with this medium tend to use the pigment too thickly.

The tools I use with this medium are watercolor brushes, sponges, painting knives, paper towels, and—as with the other media—anything that will give me the results I want.

My palette here is more extensive than usual—I really don't know why. It consists of alizarin crimson, vermilion, orange, yellow ochre, blue-green, Payne's gray, raw umber, burnt umber, ultramarine blue, black, and white. When working on small paintings (11" x 14"), I use the Pelikan box and sometimes the Marabu box both outdoors and in the studio. I change to Winsor & Newton Designers' Gouache when tackling anything larger.

Egg Tempera

Egg tempera, I promise you, will prove to be both a pleasure and a punishment— that's its fascination. Even if you find it difficult to use, you'll come back again and again until this medium deigns to let you have your way with it, and then you'll truly know the bittersweet experience that painting is.

There are many emulsions and concoctions that can be used with the powdered pigments to make them bind. Mine is simply egg yolk and water, and nothing else. I separate the egg, hold the yolk in the palm of my hand, and wash it under the tap. Then I hold the yolk by its skin over a dish, pinch it until it breaks, and throw the skin away. I add an equal amount of water, stir with a spoon, and there you are. Next, I transfer some dry pigment from the jar to a nesting cup with a paper scoop. Stirring the pigment with a brush, I pull a spot of it out onto the butcher's tray where I add a little water, shape the brush, and begin to paint. The egg yolk and water mixture acts as a medium that binds the pigment to the paper.

The brushes are, again, the pointed red sable watercolor brushes, and my favorite support is a piece of double-thick illustration board. Most artists, however, prefer a gesso panel—try both and see which you like better.

GROWING THINGS

I believe that a sketch should be done at one go; beyond that it would be a painting. Many artists return for second and third sittings until the thing is finished, but not for me the ". . . heat o' the sun, nor the furious winter's rages"; not to mention wind and bugs and wet feet! I don't think I'm alone in this attitude, so let me show you how I rush the following sketches and still seize the character of trees, tree stump, woods, and grasses.

I generally begin my sketches in one of two ways: When the entire area is to be painted, I start the blocking-in process with a tint and a pointed brush. When only one element is to be sketched—when I want to leave the support untouched and possibly erase part of the original drawing— I begin with a pencil.

DEMONSTRATION 1.

Leafy Tree

Working realistically as I do, it's understood that my purpose in sketching from nature is to capture some of her effects as faithfully and as quickly as possible. The information must be recorded accurately enough for subsequent use in the studio. To this end, I employ whatever tools will give me the impression that I seek. The tool I'll use to expedite this particular sketch of a tree in full foliage will be a synthetic sponge—the kind you use for washing dishes. Even though I love painstaking definition with a brush, my love does not extend to rendering foliage leaf by leaf.

The other conventional tools I'll use will be a piece of white matboard, Artone extra-dense India ink (black), opaque watercolor, and watercolor brushes Nos. 2 and 6. Let me point out that water jars, rinsing jars, butcher's tray, and rags or paper towels are indispensable when using any water-based medium. I won't mention them again to avoid repetition. Now let's get to work, because if you don't pick up a brush, you'll never master the art of painting—not if you were to read a thousand books on the subject!

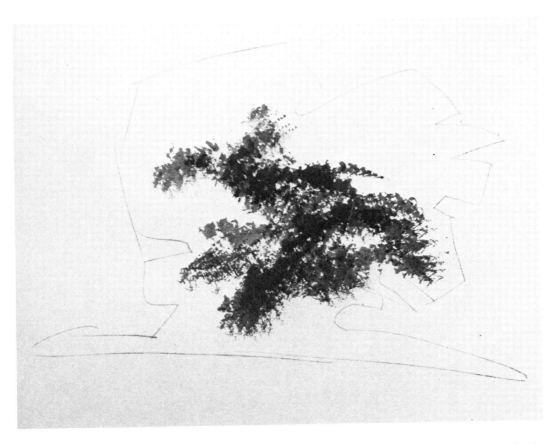

Step 1. I begin with an office pencil (sharpened with a matknife, because I prefer to work with a long lead), outlining the overall shape of the subject. It's easier for me to render shapes and to establish values within the confines of a certain boundary. Next I pour some India ink into the butcher's tray. I wet a piece of synthetic sponge—for an 8" x 10" sketch I usually cut a 3½" x 5" dishwashing sponge into quarters—and squeeze it dry. Then I tap one of its short edges first on the ink puddle and then on the board to establish the shape of the darkest values, relating their position and value to the outline.

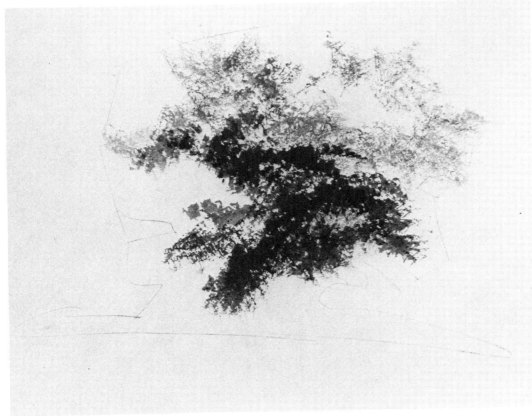

Step 2. Now I dip the sponge into the water jar and squeeze it over the puddle of ink in the butcher's tray to dilute the ink and make it lighter so I can proceed with the middle tones of the trees. I then tap *the corner and the edge* of the sponge on the paper to simulate the foliage as I see it through the window of the car.

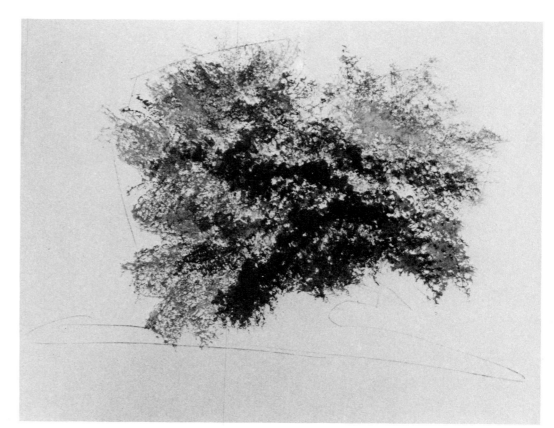

Step 3. I continue tapping the edge and corner of the sponge to get more middle and light tones. When the puddle of diluted ink in the butcher's tray is used up, I dip an old brush into the bottle and transfer more ink to the tray, where I again thin it down with another piece of sponge.

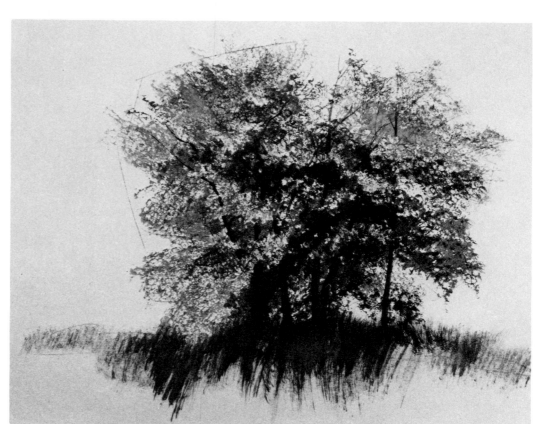

Step 4. With full-strength ink and the No. 2 brush, I do the main trunks and branches, working with a mahlstick. Then, picking up the sponge again, I rub the edge up and down to scribble the grass under the trees. It's a good idea to practice all these things even without any picture in mind so you can get an idea of the pressures required on the sponge to get certain effects.

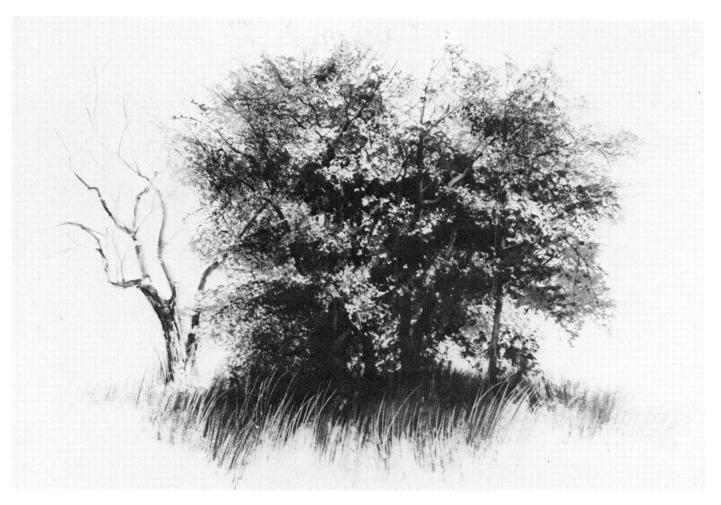

Step 5. I transfer just a bit more ink from the bottle and mix it with an old No. 6 brush on the edge of the puddle to get the last dark notes on the foliage. Then I add white opaque and yellow ochre to the ink—the yellow ochre is to warm up the grays so they'll match the warmth of the ink. I place some lights on the tree trunks with a No. 2 brush to bring them out and give them a sense of form. Next, with the same brush loaded with white and a touch of ochre, I sweep some strokes to finish off the grass I'd indicated with the sponge. Even though it wasn't planned, I include the dead tree on the left because I couldn't resist "the living and the dead" metaphor.

DEMONSTRATION 2.

Evergreen Tree

I remember that the first sketch I ever did from my car was somewhere in Nova Scotia. For some reason or other I stopped on the shoulder of the road, not intending to sketch anything. But then I noticed a juicy bit of landscape, and, unable to find a spot even for my sketching stool, I did the thing from the rear seat. It never occurred to me that the practice would become addictive, but ever since then I don't trudge through briar patches or swamps lugging the sketching supplies unless I can't *possibly* get what I want from the comfort and convenience of my car. I've learned that by pushing the front seat back, I can rest the drawing board on the steering wheel. Then, placing a box (containing the materials) in front of the right seat of the car, I can rest another drawing board on it to serve perfectly as a taboret.

I had a problem getting the character of the tree in this demonstration. I chose to work with ink again due to its ease of handling, but I used a No. 2 watercolor brush instead of a sponge. I'd like to show you that even when you use the same medium—ink—the *character* of the subject dictates the tools to be used. A sponge would be inappropriate here because it would not create the typical needles of a pine tree. The rest of the materials for this sketch consist of a piece of heavy-weight Strathmore paper, for its eggshell surface, and an office pencil.

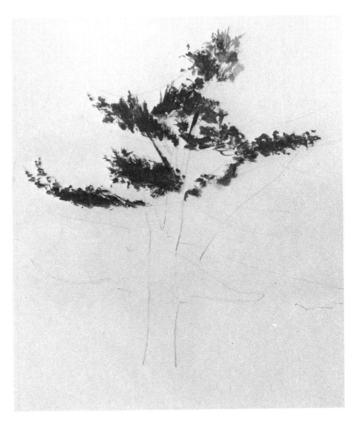

Step 1. I begin by outlining the general shape and the placement of the tree with an office pencil. Notice that I'm not attempting to describe the actual contour of the boughs—I only want to set down the distribution of the masses of needles, their relationship to one another and to the trunk. Then, using ink and the side of a No. 2 brush, I dip into the India ink bottle for the blacks and into the diluted puddle on the butcher's tray for the medium and light grays of the needles.

Step 2. I continue adding the other branches with the same brush in the same manner, applying the ink both at full and diluted strengths. At this early stage I'm not reaching for detailed and definite contours—I'll concentrate on them after I set down the main shapes in their proper places in relation to the whole, guided by the pencil outline.

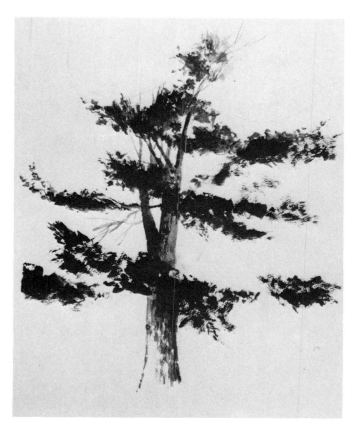 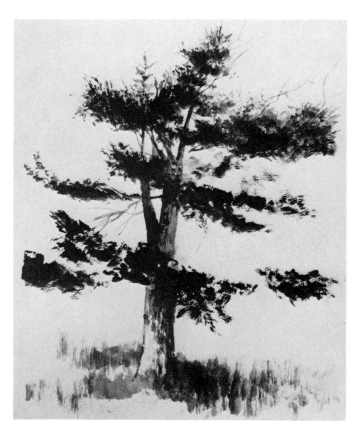

Step 3. Continuing to dip the No. 2 brush into the bottle itself, I establish all the blacks down to the lowest boughs. The pencil outline is still there, though hardly visible. I can't erase it yet because I need it for the refinements of contour and final details of the needles. But now it's time to tackle the trunk and the main branches with the tip and side of the brush.

Step 4. At this stage I erase the pencil outline—it has served its purpose and I find it distracting now when I draw the actual contour and define the character of the boughs. Since the ground is part and parcel of the picture, I do it now, scrubbing the edge of a No. 12 flat sable brush to suggest grass. With the whole design established, I return to the top of the tree and begin finishing with the No. 2 brush.

Step 5. (Right) I work my way down the tree with the same No. 12 brush, sometimes emptying it on the margin of the paper and drybrushing—dragging the brush with almost no paint across the paper. To obtain the character of the pine needles, hold it under the palm, i.e., with your palm facing the paper and your brush held firmly between thumb, forefinger, and middle finger. I do the branches next, holding the brush in the conventional manner. Finally, I darken the trunk and the grass—please note that this time I didn't have to resort to opaque watercolor as I did in the preceding sketch.

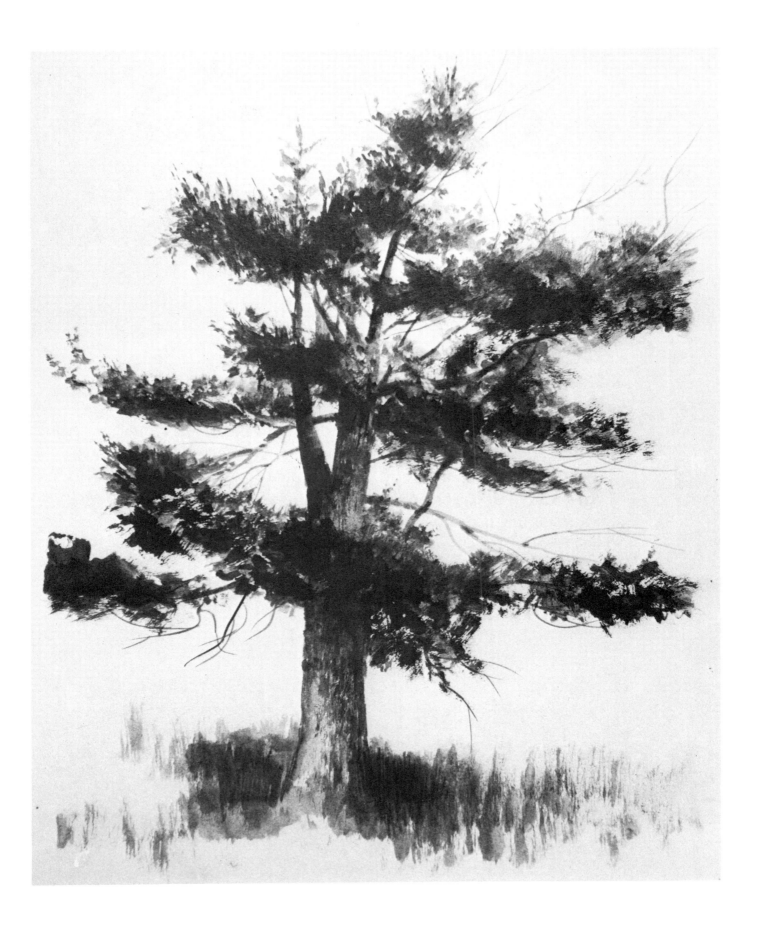

DEMONSTRATION 3.

Bare Tree

Among the scores of things that puzzle me is that deciduous trees are the only living things that denude themselves to face the blasts of winter. Whatever the reason, I'm glad they do because, as much as I love to paint them in their green or golden gowns, I really prefer the design and calligraphy of just trunk, branch, and twig.

In every painting problem it's advisable to consider the right surfaces of paper, so that it yields the character of the texture required, as well as the most efficient medium and the proper tools. Therefore, for this sketch I've chosen a Morilla pad No. 1059-S to bring you the qualities of the bare tree. I also use the raw umber and black from the Pelikan color box, because this is all the color I need for the subject, the office pencil, and brushes Nos. 1, 2, and 6.

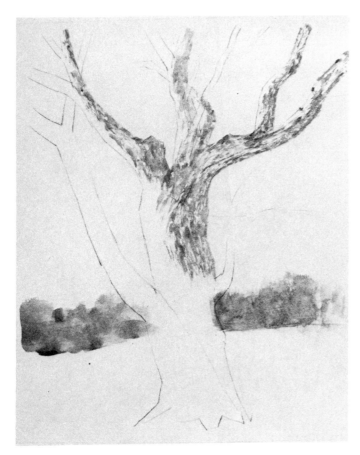

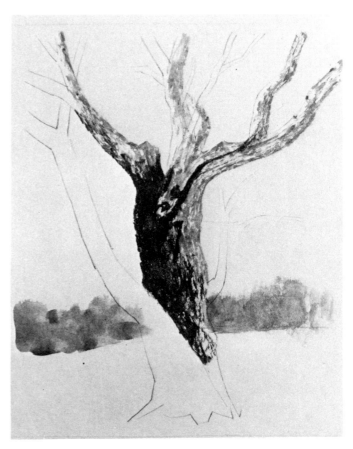

Step 1. First I use the office pencil to block in the trunk and branches—if anything goes wrong, I can easily erase the pencil marks after I paint the tree. Next, I begin to paint the light areas with very diluted raw umber and the No. 2 brush, working quickly because I realize the sun will soon set. I try to get the texture of the bark by applying the paint with the side of the brush—I use the point of the brush only when defining the edge of the branches. Then, with the same tint diluted on the butcher's tray, I scribble the band of trees in the background using a No. 6 brush.

Step 2. Still using the No. 6 brush, I dip into the black cake of the Pelikan color box, dilute it, mix it with the raw umber on the tray, and begin to shade in the shadow on the trunk. Keep in mind that I'm using the pigment in the consistency of watercolor. I apply the color in quick strokes so that the surface of the paper contributes to the texture of the bark.

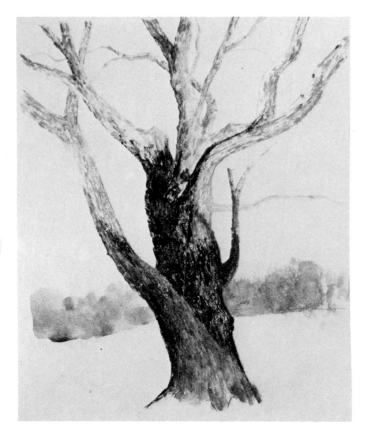

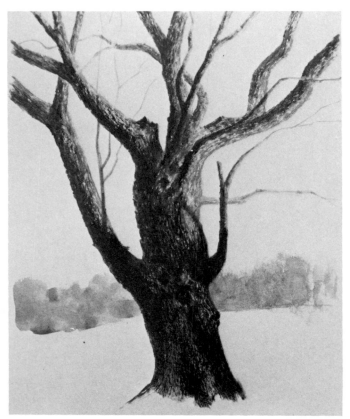

Step 3. I move over to the branch on the left. Using brushes Nos. 2 and 6, I bring it all the way down. Then I do the vertical branch midway up the trunk on the right, pinning down its cast shadow before it fades completely. Next, I tackle the two branches on the upper central part of the tree because the cast shadows on them will soon change.

Step 4. With the lights and shadows established, I can now concentrate on the detail of the bark, which I do with the No. 2 brush. The shadows are no longer the same by this time, but I adjust the tonal values to the light and shadow pattern already set down. The tree is basically done now and I could stop here, but I want all the information I can get. Therefore, I proceed with the shoots, the slender branches, and the twigs.

Step 5. (Right) Going into the finish with a No. 1 brush, I do the twigs in quick and resolute strokes. Even though the sun has set, I can still see their delicate tracery against the sky. I had intended to render the band of trees I've only broadly indicated in the background, but there's no time. If I really do need them, I'll come back another day and do a sketch of them alone. (It turned out that I did need them—for the painting in Color Demonstration 1.)

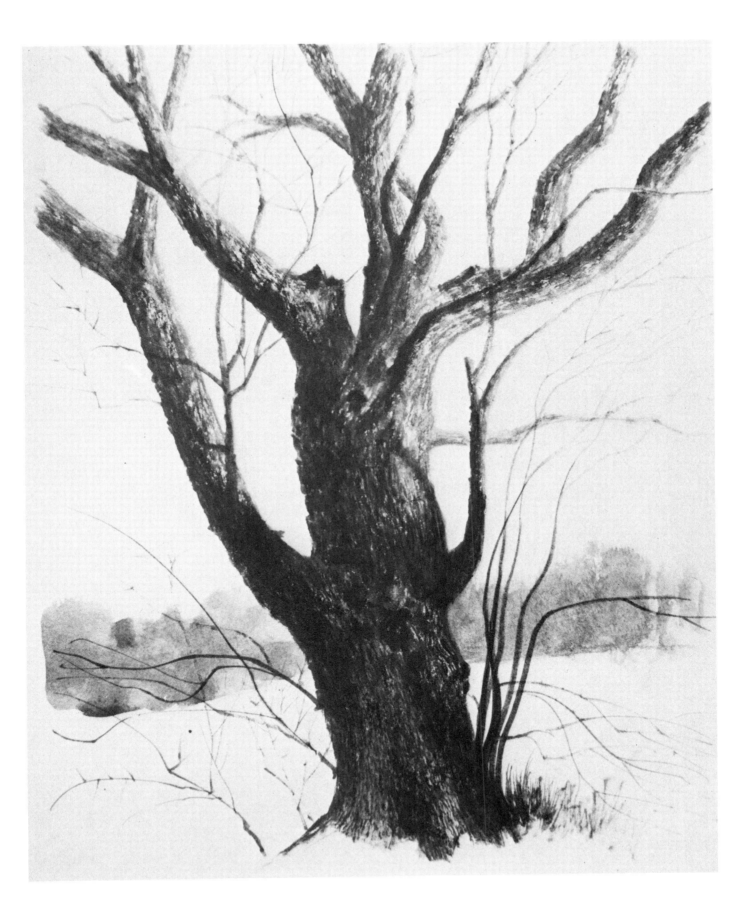

DEMONSTRATION 4.

Tree Stump

There's something poignant about a life cut short, and one of the most touching things to behold is a tree stump. That a once stately and magnificent tree had to be removed because of some dreadful disease or to make way for progress is pitiful. Anyway, when I spotted the remains of some lonely tree stumps off Highway 6A at the Cape, I quickly swerved to the shoulder, got my paraphernalia, and walked over for a close look at my subject. Placing the slant-and-well palette (containing Gamma grays from 1 to 5, plus black and white) on the butcher's tray on a sketching stool, I sat on another stool and began. I needed the flat sable brushes Nos. 1, 2, and 11, an HB pencil, and a Strathmore pad—if you haven't tried any of the Strathmore papers, I urge you to do so now. They have most inviting surfaces for any medium.

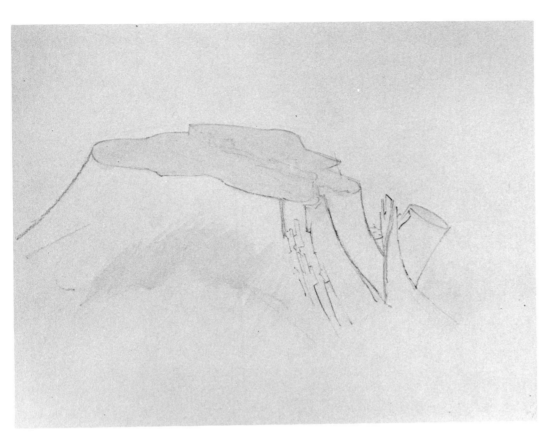

Step 1. As you see, I'm following the same approach of beginning with a pencil—this time an HB drawing pencil. When I start to paint, I transfer Gamma grays Nos. 1 and 2 from the slant-and-well palette to the butcher's tray. I mix equal parts of both tones, thin the color with a No. 11 flat sable brush, and apply it to the top of the stump. Notice that the mixture is so thin that the pencil line is not completely covered.

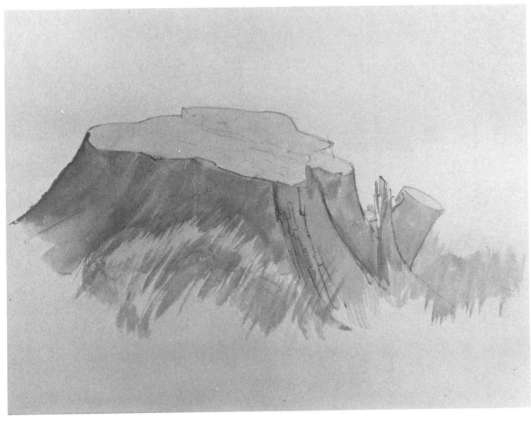

Step 2. Now I dip the No. 11 brush into the No. 3 gray and thin the color on the tray. I brush it onto the side of the stump and scribble the edge of the brush on the two patches of grass. I must stress the point that opaque watercolor—in this case the Gamma grays—must be applied thinly in the beginning stages of a piece of work. Otherwise the drawing gets lost. Later, when you're defining details or rendering textures, the paint can be used in thicker consistencies.

Step 3. Using a No. 1 brush and the No. 4 gray, I articulate the bark. The advantage of the Gamma grays is that if a certain passage doesn't come off, I can easily paint it out with the gray originally used, and try again. For example, if the bark I do here with the No. 4 gray isn't satisfactory, I'll press a damp sponge down on it, wipe the dark gray off with a paper towel, repaint with the No. 3 gray, and begin the definition of the bark all over again.

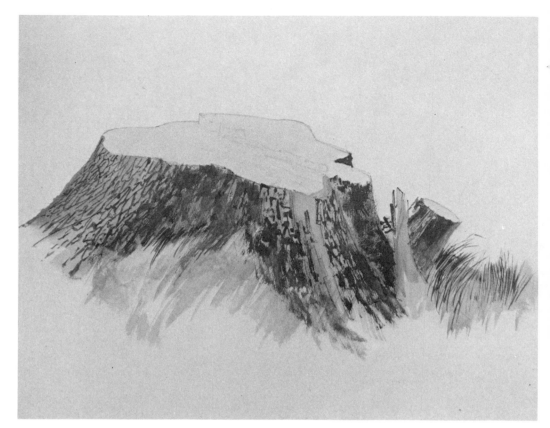

Step 4. I place the darker accents on the tree stump with a No. 2 brush and a mixture of black and No. 5 gray. Letting the No. 5 gray dominate the black, I work my way to the left edge of the stump, making the necessary refinements on the bark. Good thing I'm meticulous about detail—this stump plays a part in the painting for Color Demonstration 1.

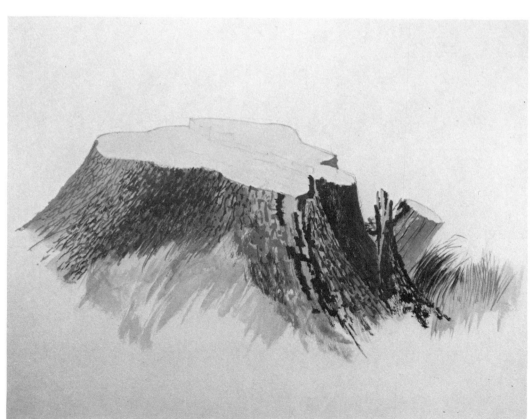

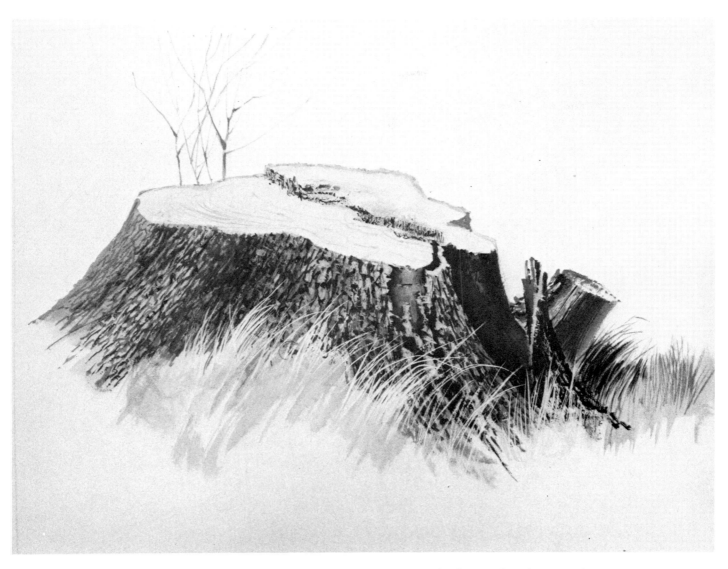

Step 5. With grays Nos. 2 and 5 plus black I finish the bark using brushes Nos. 1 and 2. Then I move to the top of the stump and render its detail with grays Nos. 3 and 5, and the No. 1 brush. I pick up some white from the Rich Art jar, thin it a bit, and shape the No. 1 brush to a point on the tray so I can execute the light blades of grass over the stump. Last I paint in the dead stalks at upper left—I couldn't help including them.

DEMONSTRATION 5.

Weeds and Grasses

No one denies that weeds are looked upon as pests that disfigure the garden and blemish the countryside. And yet, did you ever really take a close look at them? I doubt it, notwithstanding the injunction to "Behold the lilies of the field; Solomon in all his glory was not arrayed . . . ," etc. The first thing that attracted me to weeds, aside from their delicate beauty, was the thought that if a plant flourishes because it's cuddled and fawned over, then all the more credit to these that thrive in spite of complete neglect. You might say, what does all this have to do with painting! And I say everything, because no subject should be attempted without love and admiration. Naturally I'll show you how I rendered the weeds, but that's only the mechanics employed to convey my *feeling* for them. The materials for this sketch are Grumbacher Finest lamp black watercolor, Rich Art white, brushes Nos. 1, 2, and 7, and the Paper King drawing pad.

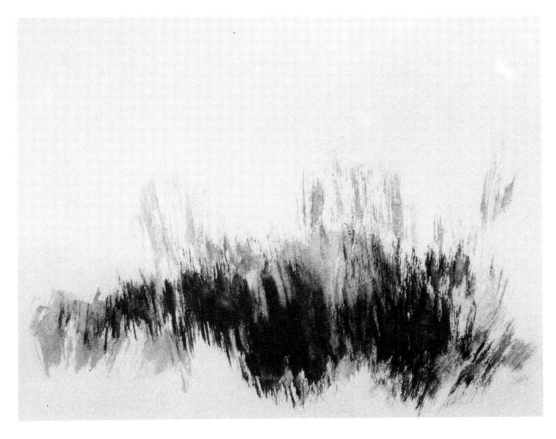

Step 1. This is one of those times when I dive straight into the sketch without a pencil indication. To get a light tone I dip a No. 7 brush into the water and work its point into the lamp black pigment. Then I scribble the first indication of the grass. Next, holding the No. 7 brush under the palm, I dip into the lamp black and pull some pigment into the puddle to get the darker tone I need. I scribble the point and the side of the brush in up-and-down sweeps, ignoring the light blades bending across the dark mass—I'll do them last.

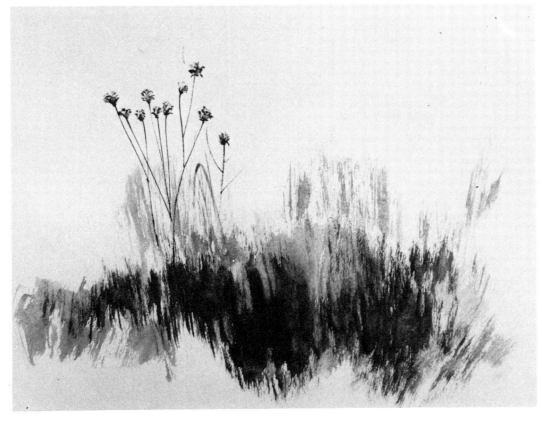

Step 2. I could have started with any of the weeds, but somehow the Queen Anne's lace caught my eye—it makes a good point of departure for me to paint the rest of the weeds. Using the No. 2 brush, I drybrush the dried up Queen Anne's lace, working the clusters into points which connect with the stems. Then I add those stems. I don't usually rest my hand on the paper itself, but I can do so now because watercolor dries so fast, especially outdoors.

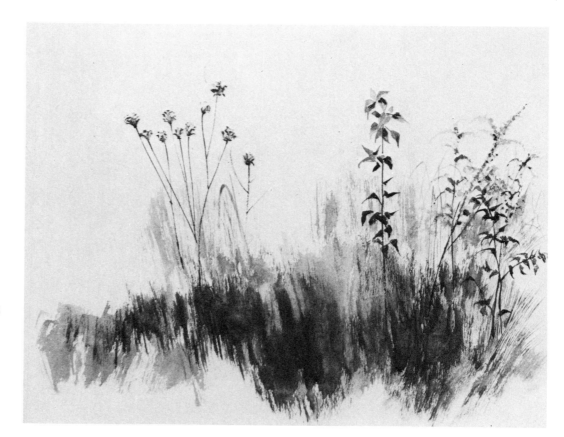

Step 3. I'm tackling the big weeds first because it will be easier to relate the smaller ones to them. I work the No. 2 brush to a point on the tray, using light and dark values depending on how much I dilute the pigment.

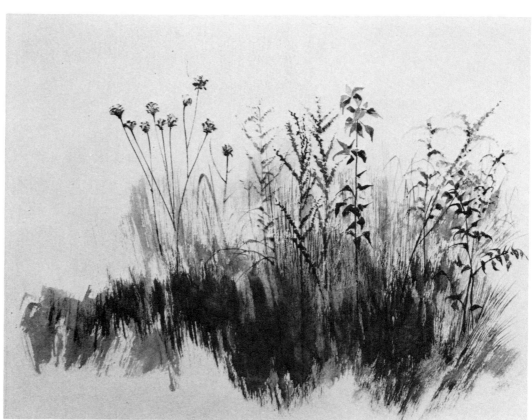

Step 4. The No. 2 brush becomes a bit awkward, so I switch to a No. 1 and continue with the more delicate weeds, relating one to another in size and in placement. Not that it would matter if I moved them about, but their actual disposition is so pleasing that I don't want to change it.

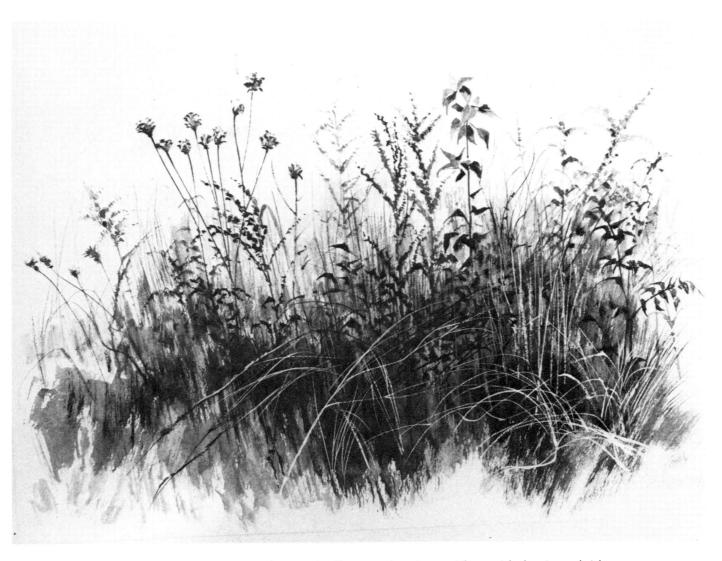

Step 5. I finish painting the weeds all across the picture. Then with the tip and side of the No. 2 brush I quiet the bottom of the grass—the zigzag edge and sharp tonal contrast turn out to be too distracting. Finally I do the light blades and stalks I mentioned in Step 1 with Rich Art white and the No. 1 brush. The resulting sketch is one of those I put to use in the painting for Color Demonstration 1.

ROCKS AND SOIL

It's interesting to note that in successful landscape painting—the school of painting that "holds the mirror up to nature"—the artist's first concern is to arrange a pleasing combination of forms and textures rather than to play with color. I'd like you to study black and white reproductions of works of Constable, Ruysdael, and Corot, to name only three masters—you'll see that color is not essential to the flawless placement of lights, grays, and darks. Why do we resort to color? Only because the sky is blue and the grass is green, and this embellishes the truth that we pursue as realistic painters. So, as you go through this book, please don't flip through the black and white demonstrations quickly—they are as instructive as any of those in the color section. The following group of sketches are of rocks, pebbles, soil, and sand—subjects that concentrate on form and texture rather than color.

DEMONSTRATION 6.

Blocky Rocks

Since the eye of the artist is caught by the minutia of nature as well as by her grander aspects of wind and weather, there's no reason why we should concentrate on the latter to the neglect of the former. Walking along the edge of a cove in Orleans at Cape Cod, I found the subject matter for this sketch and the two that follow.

The cubic rocks in this demonstration make a good exercise in composition in black, gray, and white. I know that you'll enjoy manipulating the 2½" painting knife needed for these rocks. The knife serves to prepare the sketch for the detailed rendering that follows. I'll use a No. 80 illustration board because I must have a surface sturdy enough to withstand whatever scratching and scraping I may have to do with the painting knife. The rest of the materials and tools necessary are a sponge, Gamma grays and black, an office pencil, and brushes Nos. 1, 2, and 4.

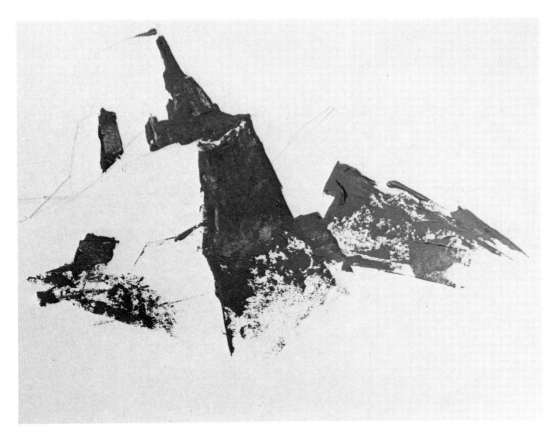

Step 1. With the office pencil I sketch the broadest indication of the two main shapes. Then I take up the painting knife, which has a 2″ blade and is trowel-shaped. I scoop some No. 5 gray from the jar onto the tray and, without diluting it, I tap the flat of the blade on the pigment. I rotate the blade on the illustration board to get the solid and textured areas—the board itself provides the texture. In effect, I let the knife take over.

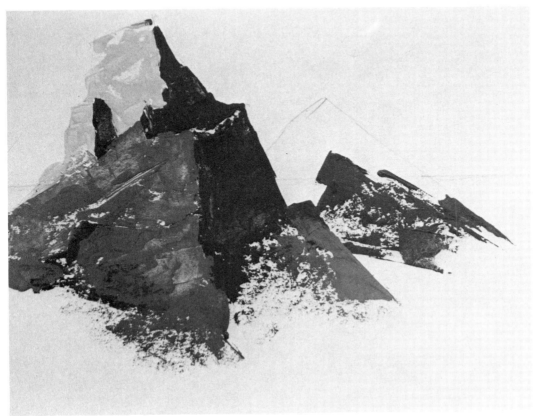

Step 2. I scoop up some of the No. 2 gray, flatten it on the tray, and apply it to the light area at the top of the main rock. Then, working my way down, I pick up the No. 4 gray, scraping and scratching with the edge of the blade. As I near the bottom of this light plane, I rotate the flat side of the blade on the board so that some of its texture can show through.

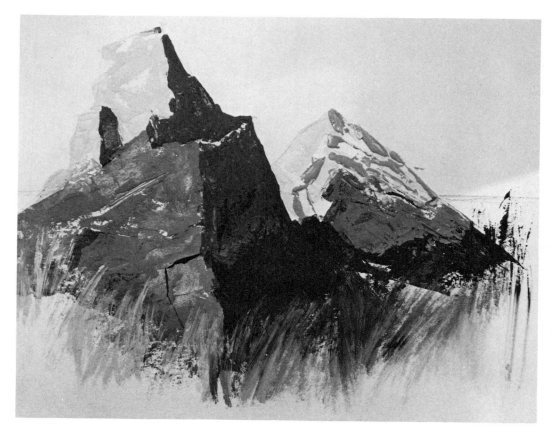

Step 3. Now with Nos. 1 and 3 grays I begin the second rock. I decide to kill the texture done in the previous step when I rotated the knife because that texture conflicts with the grass that's coming up next. Therefore I cover the base of the front rock with black. Continuing with black, I do the weeds at the extreme right with the edge of the blade. At this stage I've got all I want from the painting knife, so I switch to a sponge to suggest the grass with a No. 2 gray.

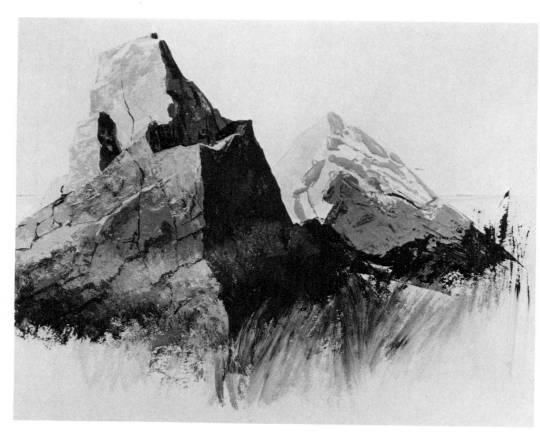

Step 4. To finish it completely, I concentrate on the foreground rock. With the tip and side of brushes Nos. 1, 2, and 4, and grays Nos. 1, 2, and 3, and black, I begin at the top and work my way down articulating cracks, correcting values, and refining details. Keep in mind that the texture I achieve now wouldn't be possible without the painting knife groundwork.

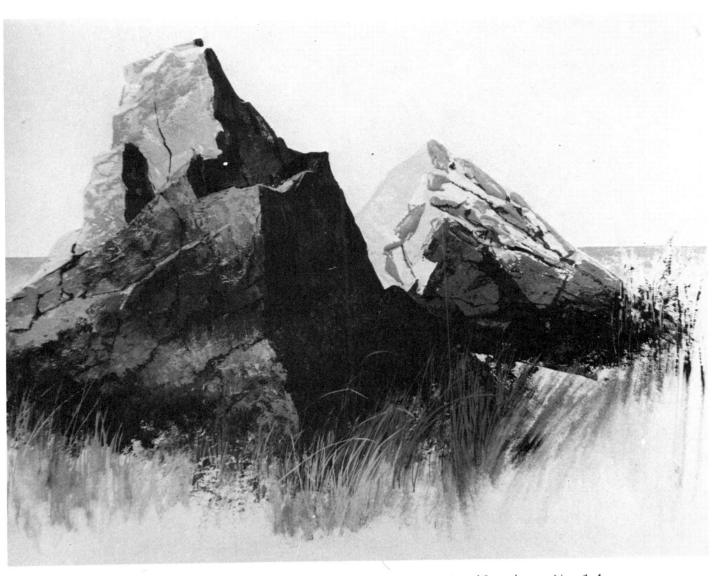

Step 5. Now I finish the second rock with brushes Nos. 1 and 2, and grays Nos. 1, 4, and 5, setting down details that the painting knife couldn't achieve. Next, with Nos. 1, 2, and 4 grays, I finish the grass with the No. 1 brush. Then I pick up a No. 3 gray and add the bay in the background. To finish off, I add the reflected lights with a No. 4 gray in the shadow area of the foreground rock.

DEMONSTRATION 7.

Rounded Rocks

A few paces away from the rocks in the previous demonstration I found this giant specimen that has sat for many a portrait for artists in the area— no doubt it will continue to sit for generations to come. While the painting knife lent itself to the effect I wanted when painting the angular rocks of Demonstration 6, I relied on riffling, or spatter, to reproduce the beautiful texture of these rounded rocks. I must stress the point that there's a specific tool for every effect and impression we want to create. Not that the same results can't be obtained by conventional rendering with a brush, but the time required would be unthinkable when sketching and the outcome wouldn't be any more faithful to the subject than the expeditious application of an unorthodox tool. So, get a new toothbrush and collect your Gamma grays, white and black opaques, buff matboard, painting knife, synthetic sponge, brushes Nos. 1, 2, and 6, and an office pencil.

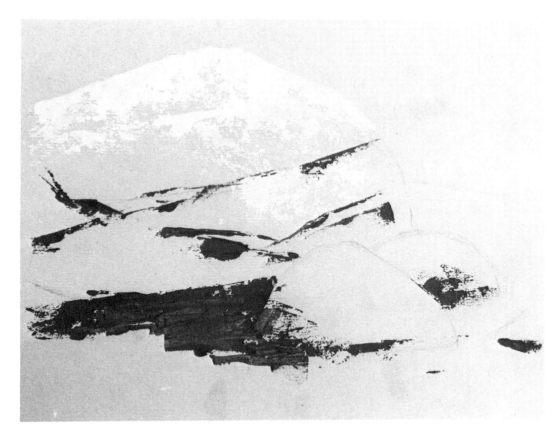

Step 1. First I make a brief drawing on the matboard with an office pencil. Then, taking up the painting knife again, I scoop some white paint from the jar and place it on the butcher's tray. Without diluting this paint, I flatten it, i.e., push it against the tray. Then I pick some of it up and begin to cover part of the pencil drawing with the paint on the flat side of the blade. When this lightest tonal value is established, I look for the darkest and decide that I can go all the way down to black. I rinse the painting knife in water, wipe it, and apply the pigment straight from the jar with its edge. I hope that you're doing these sketches—or similar ones—along with me, so that you can discover what the tools I'm using can do.

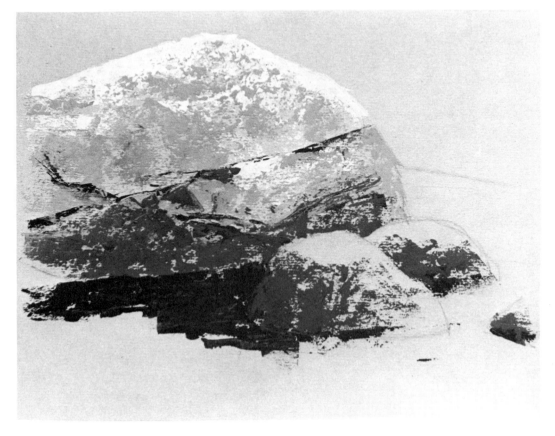

Step 2. As in the preceding demonstration, I plan to carry this sketch as far as I can without resorting to any brush. Therefore, I apply a No. 3 gray with the flat of the blade to the sketch. I work the gray into the white, while letting some of the buff board show through. I trim the white into patterns resembling those on the actual rock. Then I do the shadows on all the rocks with undiluted No. 5 gray.

Step 3. I have used the painting knife as much as possible. Now, dipping into the No. 5 gray, I load a clean toothbrush with paint and riffle the bristles close to the painting for the big dots. By riffle I mean take your forefinger and, holding the toothbrush close to the paper—so you don't get paint over everything around you—run your finger along the bristles of the brush. The paint will spatter onto the paper. For the smaller dots I empty the toothbrush onto the butcher's tray before riffling. Notice that the paint spattered all over the paper in spite of my precautions. Next I took a sponge, dipped it into the No. 2 gray, and tapped the flat side onto the bottom of the paper to indicate ground.

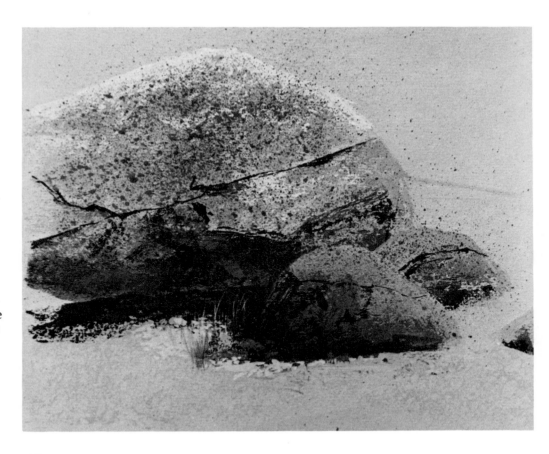

Step 4. Now I want to riffle white paint onto the sketch. Not wanting to spray any more paint beyond the rock itself, I cut the shapes of the rocks out of paper to make a stencil in order to block off the sky and the ground. Then I spatter undiluted white paint with the toothbrush as before. The white dots will spatter *only* the rocks. Then with black and No. 5 gray and brushes Nos. 1 and 2, I rearticulate the dark cracks.

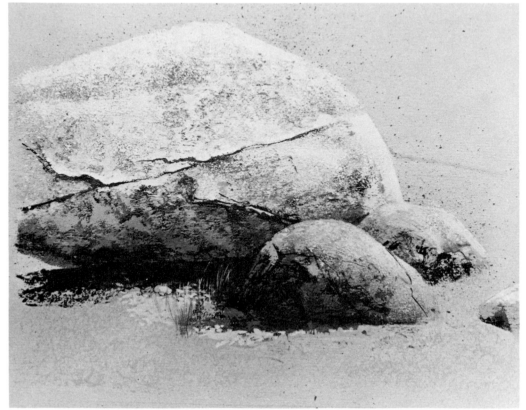

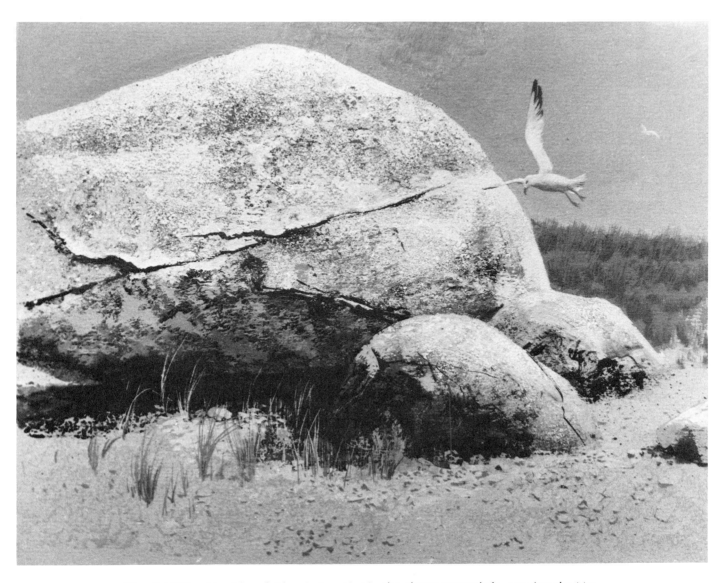

Step 5. With a No. 6 brush I begin to paint in the sky at upper left, carrying the No. 1 gray across the top of the rock where I blend—wet-in-wet—a No. 2 gray and continue onto the right side of the picture. This is an old device used in emphasizing light direction (in this instance the light source comes from upper right). The wet-in-wet refers to the technique of painting with a fully loaded brush on damp paper. Then I do the grass behind the rocks with grays Nos. 3 and 4, and a No. 1 brush. Moving to the foreground, I do the grass with a No. 2 gray and No. 2 brush, accentuating some of the shapes the sponge had suggested on the ground. Finally I add the gull to convey the size of the boulder.

DEMONSTRATION 8.

Wet and Dry Pebbles

At the same cove on Cape Cod where I drew the two preceding sketches, I was struck by the beauty of these rocks and pebbles. Some of them were completely submerged, while others came up for air. To me, everything, even something as inert as a rock, is imbued with life. You can consider my views or, of course, reject them, so long as you remember that "painting is another word for feeling."

These pebbles are one of many subjects that will *not* submit to anything but a brush. The materials I put to use here are an office pencil, the Symphonic watercolor set No. 3017 by Grumbacher—the lid of the box is divided into compartments where I mix my colors—a fine-grained synthetic sponge (for the big rock), and brushes Nos. 1, 2, 3, 4, and 6. The paper is a sheet from the Morilla pad No. 1059-S.

Step 1. Using the office pencil I sketch a very broad indication of the big shapes. Then, using the black from the Symphonic watercolor box, I paint the crack and base of the large rock on the right with the point, side, and heel of the No. 1 brush. Changing to a No. 6 brush and switching to brown deep and yellow ochre, I paint in the reflections of the rocks on the puddle. With green, brown deep, black, and the No. 6 brush, I paint the shape at upper left. Then I make a few scratches with the corner of a razor blade to see how the grass would work in this area. I prepare the required values of the green, brown deep, and black—light and dark, cool and warm—for the rock on the right and paint it in. Next I add a wash of flat ochre to the left of that rock.

Step 2. With the No. 6 brush I dip into the gray-green wash that I prepared for the large rock and float it over the rest of the shape that is to be the puddle. Then, with the same brush, I cover the rest of the ground with a wash of brown light, tempered with a spot of green and yellow ochre. I don't premix these colors—I dip into them one at a time to get a variegated effect instead of a flat tone.

 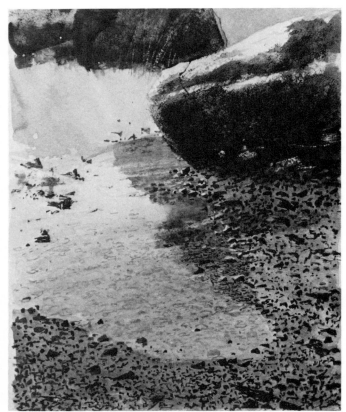

Step 3. The submerged pebbles in the puddle come next—I do them with a No. 2 brush and a very thin brown deep. Then I dip into the white with a No. 3 brush and make a thin wash on the tray. I sweep in diagonal strokes across the light area of the puddle into the rock reflections to suggest the wind stirring the surface of the water. Next, I indicate the rocks on dry land with brown deep, a touch of black, and the No. 3 brush. I've also scratched some of the rocks in the shadow of the big one with the razor blade.

Step 4. Now I rub the pebbles under the water with a damp No. 4 brush because they're much too distinct to convey the idea that they're submerged. I continue with the pebbles on dry land with a No. 2 brush and the brown and black mixture from Step 3. I'm tempted to finish the big boulders, but I concentrate on the pebbles, both wet and dry. I do, however, define all three boulders by separating the two at upper left and by deepening the tone of the one on the right with the sponge.

Step 5. (Right) Continuing to work on the boulders, I do the two at upper left with the No. 3 brush dipped in brown deep, black, and green. Then I pick up white, mix it into these three colors and lighten the top of the middle boulder to give it form. I notice that the lower diagonal strip of light on the main boulder makes a hole in the composition so I kill it by tapping deeper tone over it with a sponge. Returning to the No. 3 brush, I dab the topsides of the pebbles with a touch of white mixed with yellow ochre. Finally, with green and yellow ochre, and the No. 1 brush, I render the grass at upper left.

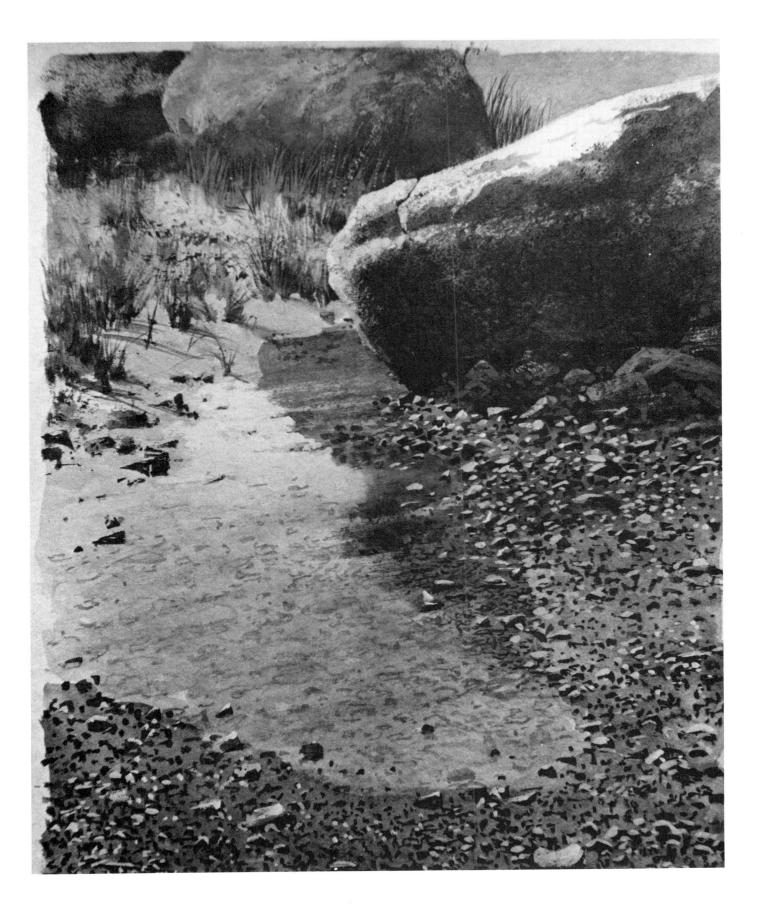

DEMONSTRATION 9.

Ground

As a teacher I've heard countless complaints from my students that there's nothing to paint where they live. But I disagree, and I should like to put it in another way. It could very well be that nothing in your area is *appealing* to you—this, of course, is valid. As I've said before, *you must love the things you paint*. You may hanker to paint the sea while living in Arizona or long to do the desert from a flat in Brooklyn—but you can't, with any conviction, unless you use a photograph. I suggest that for the time being you sketch everything around you, because it may spark an interest you haven't felt before. Even if it doesn't, training your hand and sharpening your vision will give you the facility to do justice to the subjects you love when you eventually find them.

I picked the spot on the Cape where I sketched this demonstration because, even though the ground is devoid of the exciting big shapes that attract me, it does have qualities such as quietude, expanse, and lonesomeness which make it worth painting. Remember—I'll put it simply and forcefully—*paint wherever you are*.

To sketch this demonstration with me, gather together a sheet of Fabriano watercolor paper, Van Dyck brown, Rich Art white, flat sable brushes Nos. 12 and 20, and watercolor brushes Nos. 2, 3, and 6.

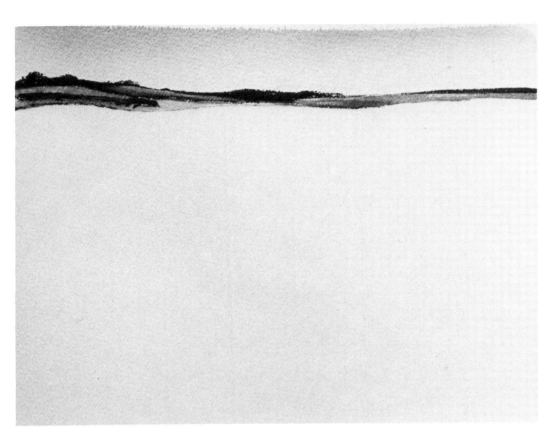

Step 1. First I put on a simple graded wash. I squeeze a ¼" of the Van Dyck brown onto the tray, dip the No. 12 flat sable into the water jar, touch the pigment with the edge of the brush, and draw the brown out into the water puddle. I draw the corner of the brush with the slight color tint across the paper, indicating the horizon line. Next, beginning at the top of the sky, I dip the brush into the pigment once, then the water as many times as necessary to spread the diluted pigment in horizonal strokes down to the horizon line. With more brown pigment and less water, I work the far distance with the side and tip of a No. 2 brush. I drag the brush on the Fabriano paper so that its texture will suggest the foliage of distant trees.

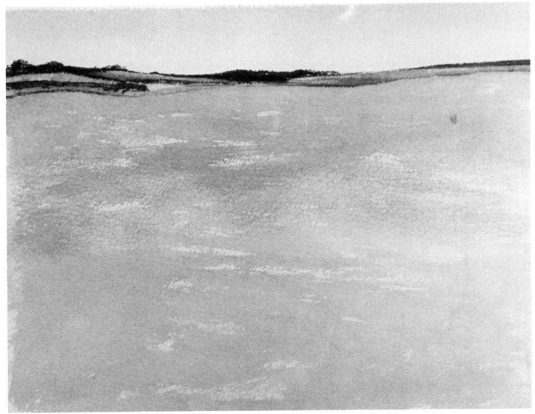

Step 2. I cover the ground with a scantily charged No. 20 flat sable brush in quick horizontal strokes—I leave some of the paper showing so that the texture of the paper shows through in this area. As in Step 1, I dilute the color as I go along because I don't want an even tone.

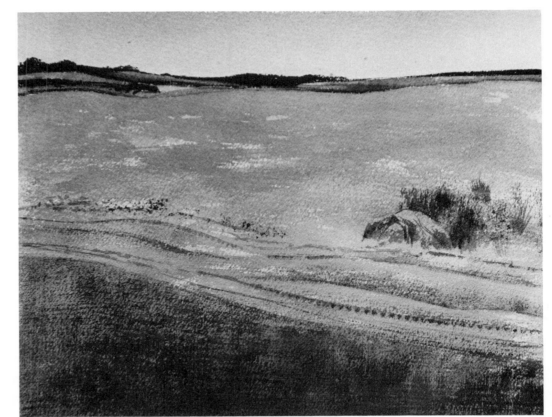

Step 3. Dipping into more brown pigment to get a darker tone, I drybrush the foreground with a No. 6 brush. Then I shape the brush again on the tray in order to do the rock and the adjoining weeds on the right. While the brush is still shaped to its point, I begin indicating the road and the tire marks. Notice the important role the texture of the paper itself plays—this happens often with watercolor.

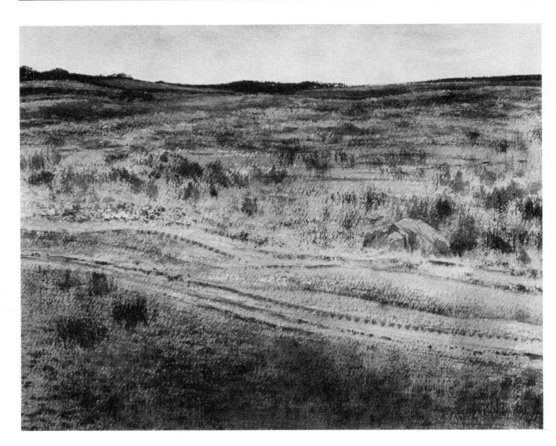

Step 4. After drybrushing more dark value into the foreground, I move to the middle distance. With the side and heel of a No. 3 brush held under the palm, I pat the brush on the paper and then sweep upward to articulate the grass and the weeds. This use of the side and heel of the brush may be new to you, but I do hope you try it— you should utilize more than just the tip of any brush.

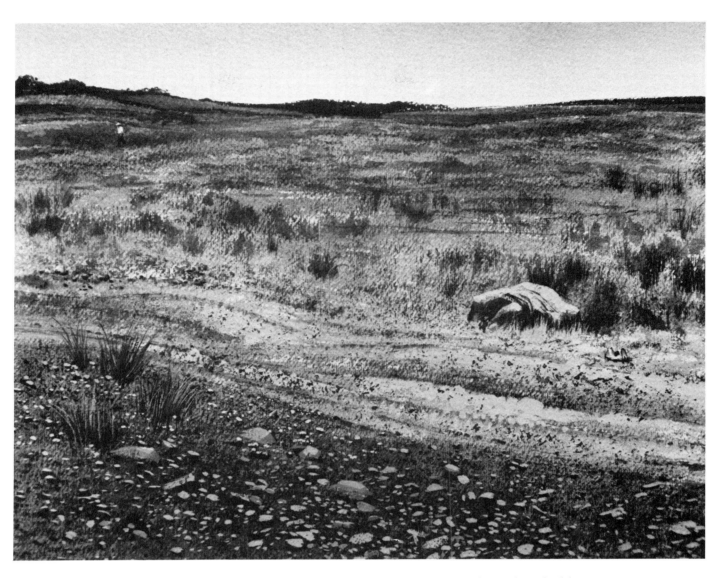

Step 5. I tackle the final details by deepening the shadow on the rock and adding pebbles on the road. Then, dipping into white paint with a No. 2 brush, I subdue the tire marks because they were too prominent. Picking up more white to make it thicker, I move first to the rock and paint in its light plane and then to the right to render the discarded beer can with a No. 1 brush. Working my way down to the foreground, I add more rocks and pebbles. The last thing I do is add the tiny figure at upper left to give the scene its proper scale.

DEMONSTRATION 10.

Sandy Beach with Pebbles

Poets, composers, and painters (notice that in all modesty we put ourselves last) have all praised the sea since time immemorial and will continue to do so forever. There's something irresistible about its myriad moods, from its blackest and most violent to the gentlest and most soothing. During World War II, when I set forth as a sailor to recapture the Pacific—naturally with the aid of the other military services—I did countless sketches of the open sea in every conceivable mood. (The point I'm still emphasizing is that though I prefer the shapes and textures of shores and beaches to the monotony of wave after wave or swell after swell, I always paint—I am compelled to—wherever I am.) Imagine my excitement, then, when I found this ready-made picture at Sagamore Beach on Cape Cod Bay. As I sketched it with this book in mind, I noted the materials needed: Artone India ink, white opaque, the Morilla pad No. 1059-S, flat sable brushes Nos. 12 and 18, and watercolor brushes Nos. 2 and 6.

Step 1. First I dampen the sky area with clear water using a No. 18 flat sable brush. Then I pour some India ink into a saucer and place it on my butcher's tray. I touch the tip of the same brush into the ink to transfer some of the ink to the tray, dilute the ink with water to get the light tone I want, and then apply it in horizontal back-and-forth strokes to the dampened sky area. Quickly, while the sky is still wet, I load a No. 6 brush generously with undiluted ink straight from the saucer and work it across the bottom edge of the sky, so that the ink blends with the wet wash to give me feathered edges suggesting the foliage of the distant trees. Practice this—the wetness of the surface determines the softness of the edge.

Step 2. I continue with the No. 6 brush, using its point to articulate the contours of the sand banks and its side to fill in their tone. Then, with a lot of water and a spot of ink, I delineate the edge of the beach because the tide is at dead ebb and will soon start to change.

Step 3. I pick up the No. 12 flat sable brush and, with a gray I premix on the tray, I cover the entire beach area. Notice how important it is to select the right paper for a particular subject. The surface of the Morilla paper gives me a perfect sandy effect simply by floating a wash over it.

Step 4. With the No. 2 brush I do the spots of sand and pebbles protruding above the water next to the big sand bank. Then with the same deep gray I articulate dark sand and pebbles on the beach itself. I decide that the whole beach should be darker so I give it another wash with the No. 12 flat sable. Now the disposition of light, gray, and dark shapes in the picture makes a more forceful design.

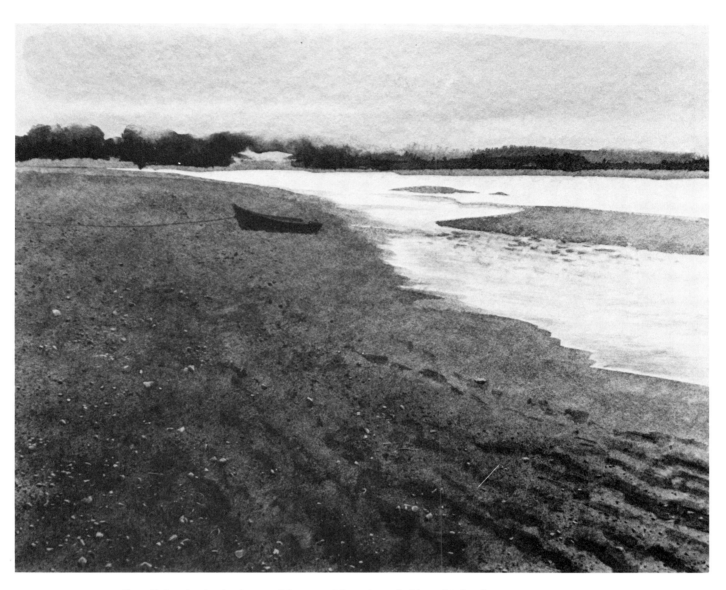

Step 5. I paint in the boat with a No. 2 brush and diluted ink. Then I move over to the beach to render the pebbles. I already indicated their dark undersides in Step 4. Now I dip into the white opaque and mix it with the ink on the tray to get the light value I need to bring them out. Finally I articulate the edge of the surf with touches of light gray that show the sand under a thin film of water.

DEMONSTRATION 11.

Sand Dunes

Although, as you know, I prefer to sketch from the car, this time I had to go to the dunes on foot, and at times even on my knees. But I'm glad I searched and found the right spot. I've mentioned that it's the artist's business to arrange and compose because nature hardly ever presents him with a ready-to-paint picture. Well, this scene and the one in the preceding demonstration are exceptions, and I'm sure some day there'll be others. It was very windy on this particular day—I even had to stretch a rubber band on the end of the pad of paper to keep the sheets from flapping. By the time I finished, I had sand in my shoes, in my hair, and in my teeth; but it was worth it. This sketch, with minor modifications, became the painting for Color Demonstration 2.

I used the Paper King pad, the office pencil, Payne's gray, and brushes Nos. 2, 3, and 9.

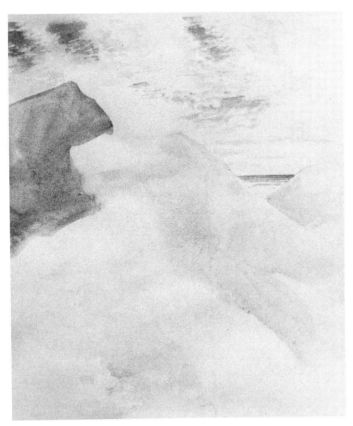 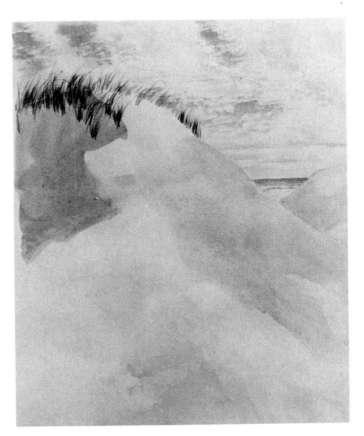

Step 1. First I lightly draw the shape of the dunes with an office pencil. Then I squeeze about ¼″ of Payne's gray into a clean white saucer. With a No. 3 brush, I dilute the gray and brush it on the dry paper, letting the paper itself describe the shape of the cirrus clouds. Then I indicate the shadow on the left of the large dune with a No. 9 brush and Payne's gray. I rinse out the brush and wet the smaller dune and the light (right) side of the large dune with clear water. Dipping the brush into the pigment to get a light tint, I work the gray on the wet surface to get the soft-edged configurations you see here.

Step 2. Dipping the No. 2 brush into full-strength Payne's gray, I begin rendering the grass in swift, upward strokes—from the bottom up, as grass grows. I dilute the gray here for the lighter passages.

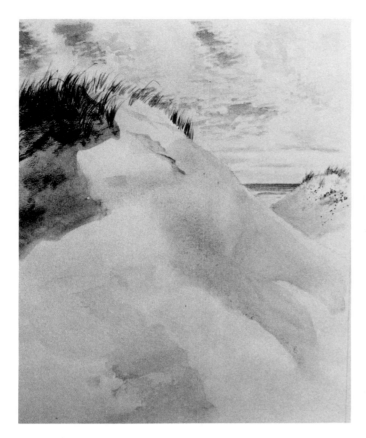

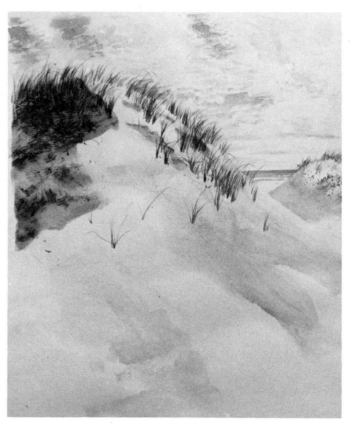

Step 3. With the side of the No. 2 brush I develop the dead grass and roots on the shadow side of the big dune. As you see, I paint the grass in the back first—I think that things in front should be superimposed on those behind. At this stage I also begin indicating the grass on the smaller dune to the right.

Step 4. This is the simplest step of all—I just continue to add more grass in the manner already explained in Steps 2 and 3. Then, still using the No. 2 brush, I introduce a few more details into the shadow area of the main dune. As I work in the studio, redoing this sketch in its proper stages for my photographer, I try to recall the wind in my ears and the sea air in my nostrils so I can again do justice to the scene.

Step 5. (Right) I continue painting the grass on both dunes. When the grass itself is finished, I paint the shadows it casts in deep values to show the strong sunlight that bathes the scene. Then, to reinforce the atmosphere of the place, I introduce the gulls, hoping that the spectator will hear their cries and feel an intensified response to the picture I've just transcribed.

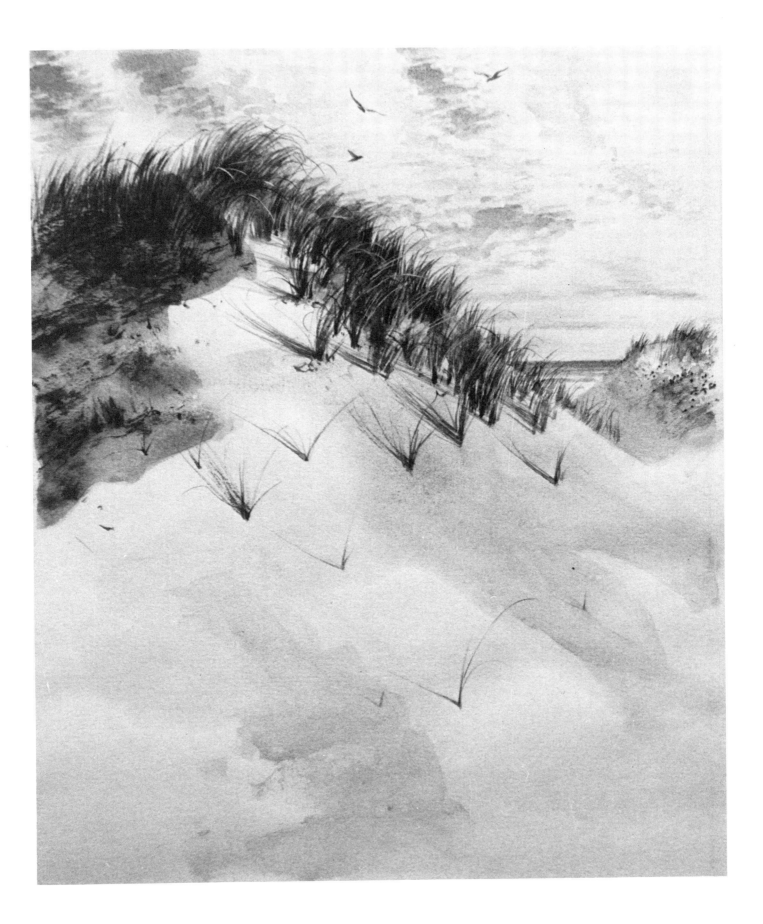

SKIES AND WEATHER

To capture different phases of weather, you need a lot of patience, some luck, and great perseverance. In the following eight sketches I had a little of each.

DEMONSTRATION 12.

<div style="border:1px solid">

Clear Sky

</div>

The simplicity of the graded wash—a graded tone blended wet-in-wet—plays a major part in landscape painting. The sky is gradated to prevent it from being a mere backdrop, not to make it suggest the dome that the sky appears to be to the eye. If you take a good look at a clear sky some day, you'll notice that it becomes lighter as it nears the horizon. If I were to paint this sky in the same tone from top to bottom, it would give no depth to this picture; the sky would be on the same plane as the boat in the foreground in this demonstration. I must also add just one more thing—a clear, plain sky should serve as a background that quietly complements any complex or intricate detail sketched over it.

The materials I use for this sketch are white matboard, the Gamma grays in the slant-and-well palette, black and white opaques, a ruler, an HB pencil, flat sable brushes Nos. 12 and 20, and watercolor brushes Nos. 1, 3, and 5.

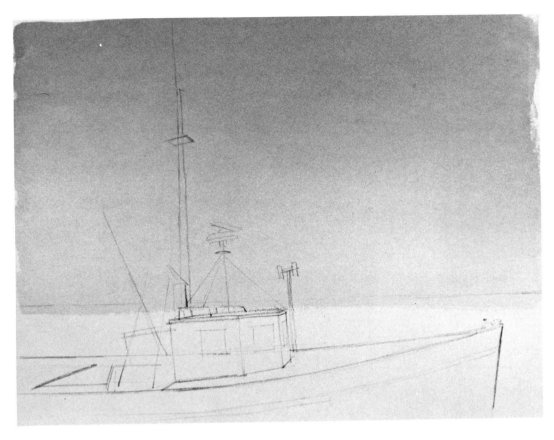

Step 1. First I wet the matboard with a No. 20 flat sable brush and then quickly dip into the No. 3 gray. I brush this gray on in horizontal strokes at the top of the sky, rinse the brush, dip into the No. 2 gray, and blend that gray into the lower edge of the No. 3. Then I repeat the procedure, blending a No. 1 gray at the bottom into the No. 2. The sky becomes partially dry quite soon, so with an HB pencil I sketch a rough and simple indication of the fishing boat. Please note that when I do the lines projecting into the sky, I place a piece of paper under my hand to avoid smudging.

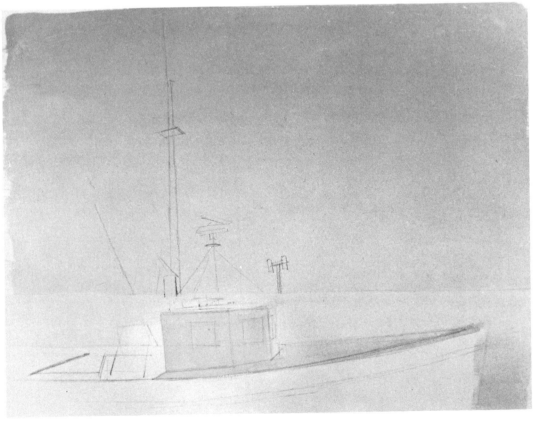

Step 2. Combining a touch of No. 1 gray and pure white with a No. 12 flat sable, I do the water, adding a bit of No. 3 gray as I reach the lower right corner. As you can see, I paint right across some of the smaller elements on the boat—the pencil lines remain faintly visible. Then, using a No. 5 brush, I float a much diluted No. 3 gray over the cabin and the deck.

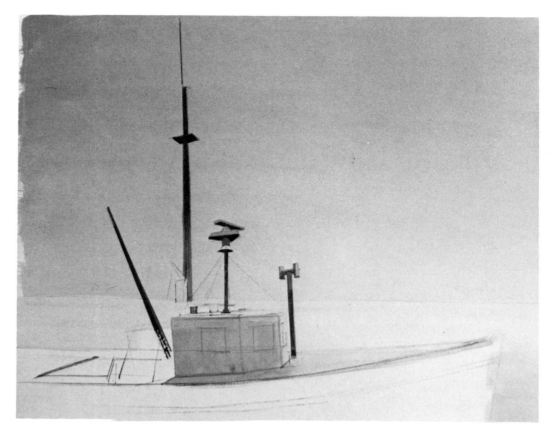

Step 3. With the No. 3 brush I paint all objects which project into the sky, including the boom and the mast, with grays Nos. 3 and 5. For all these elements I rely on the ruling method—I create straight lines in paint with a ruler and a pointed brush. If you haven't yet mastered this method, I urge you do so now.

Step 4. Still using the No. 3 brush, I add the dunes and the trees in the distance. After lightening the water on the left a bit, I switch to a No. 5 brush and a No. 5 gray and continue with the rest of the boat. Keep in mind that I'm doing the boat only to show that a delicate and complex detail should have a simple clear sky behind it to bring it off.

Step 5. By this time the sky is completely dry—as I glide my hand along the ruler with the No. 1 brush to do the rigging, I don't worry any longer about smudging. I scumble (rub with the side of the almost empty brush held under the palm) some black on the hull and on the interior of the wheelhouse. Then I highlight the boom holding the net. Finally I add the bowlines and make other tonal adjustments. This sketch of the boat is really only a rough indication—there are many details I haven't included.

DEMONSTRATION 13.

Cumulus Clouds

One of the things I learned long ago while I was devouring the art books at the Los Angeles library was that the sky must correspond to the landscape. This entire sketch is devoted to the clouds alone, with only a strip of land to show the immensity of the sky (with modifications, I put these clouds to use in the watercolor in Color Demonstration 5). If you have the time, try to find the reproduction of two of Constable's paintings, *The Hay Wain* and *The Corn Field* for other examples of cumulus clouds in paintings. You'll see how the contour of a tree is picked up by the edge of a cloud to pull the picture together and to create the rhythm that should exist between one element and another.

As usual, I chose the materials that would give me what I wanted in the shortest amount of time: gray matboard, white Conté pencil, General's 4B charcoal pencil, a matknife, a sandpaper block, and a paper stump.

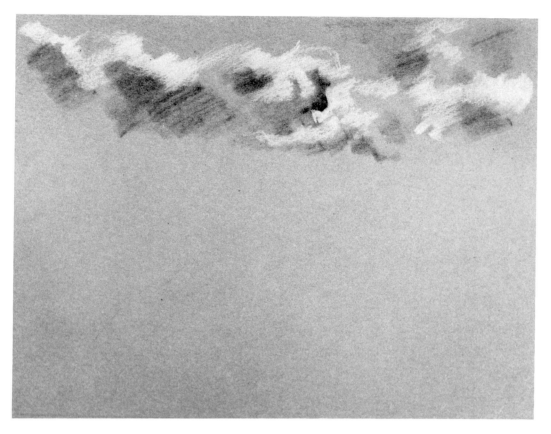

Step 1. Before I begin this sketch, I sharpen the charcoal pencil with my mat-knife and rub it on the sandpaper block over a dish to collect the powder. Then I twirl the end of a paper stump in the powder, roll it on the margin of the matboard to discharge some of the charcoal, and begin to sketch in the top edge of the clouds, turning the stump as I proceed. I work rapidly because even in a slow wind the shapes of cumulus clouds change much too fast. Switching to a white Conté pencil I do the light areas of the top clouds.

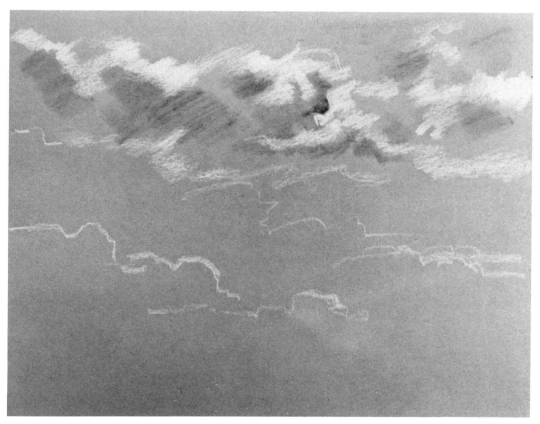

Step 2. I continue with the white Conté pencil, holding it in the conventional manner to get values slightly lighter than the gray of the board itself. When I want intense whites—as I do for some of these clouds—I hold this pencil under the palm, placing my forefinger right on top of the crayon so that it won't break when I increase the pressure. If the Conté pencil needs sharpening, I use the mat-knife again because it tends to break when sharpened with a pencil sharpener.

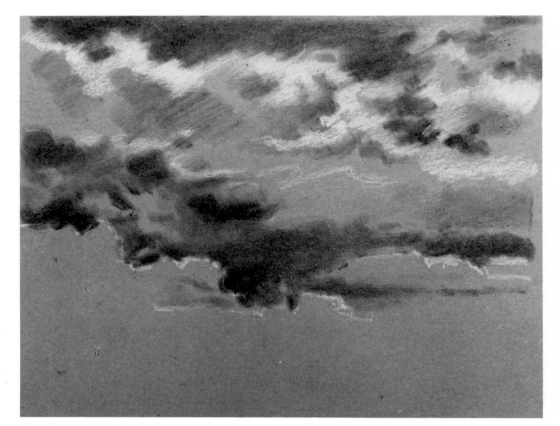

Step 3. I return to the charcoal powder to draw the sky with the stump in a tone that's deeper than the shadows on the clouds so that the clouds stand out clearly against the sky. Of course, I keep my hand off the matboard or I'd certainly smudge it.

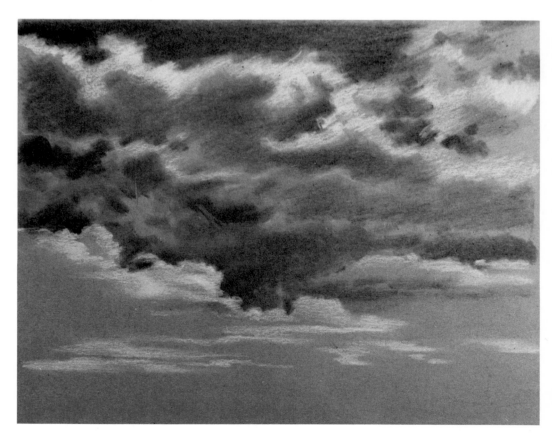

Step 4. Going back to the white Conté pencil, I pin down contours quickly, adding light areas to the lower sky. I must mention that both darks and lights are exaggerated—I'm after clear and definite shapes for future information.

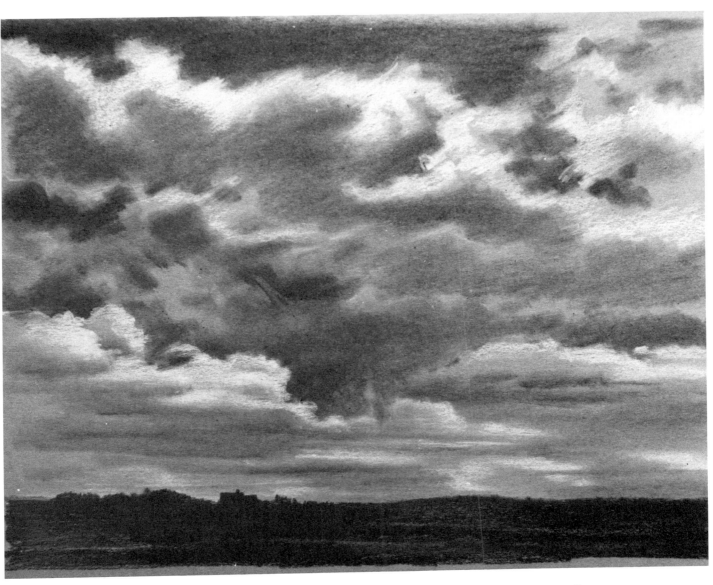

Step 5. I've retained as much of the chipboard's gray tone as possible to expedite this sketch. Now with the charcoal pencil itself I draw the ground and use the paper stump to work the black into the board. I don't do this too vigorously—I don't want to kill the texture of the board because I want it to contrast with the soft, vaporous clouds.

Cirrus Clouds

Cirrus clouds have been a challenge to me ever since I began painting. They look so deceptively simple to do that I was amazed they didn't come off in my first attempt. I simply concluded that it was just one of those days when nothing turns out well and gave it no further thought. But when my second and third attempts were dismal failures, I began to worry. No matter what approach I tried—painting around them and leaving the paper itself for the clouds or coating a board and then painting them on top—the result was invariably a frightful mess. The thought crossed my mind one day that it might be possible that there was something I couldn't paint! Deciding that that was preposterous—absolutely unthinkable—I persevered. By dint of hard work and unremitting observation I finally succeeded. The moral for all of us is that if anything proves difficult, persevere and forge ahead.

The materials I used are an office pencil, the Gamma grays and white opaque, a piece of gray chipboard, a No. 20 flat sable brush, and watercolor brushes Nos. 2, 3, and 6.

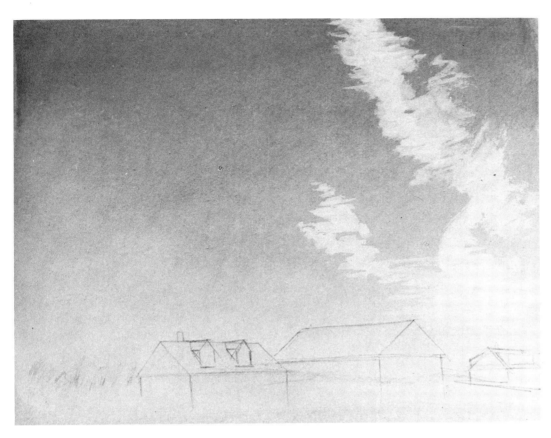

Step 1. I'm using gray chipboard again not because I want to use its tone as part of the picture, but because it's a cheap, firm support. With the No. 20 flat sable brush I grade the sky wet-in-wet, just as I did for Demonstration 12, beginning with a No. 3 gray, blending first into a No. 2 gray, and then into a No. 1 gray at the bottom. Next I indicate roughly the disposition of the beach cottages with an office pencil so that I can design the lower sky in relation to them later. Then I dilute some Rich Art white and begin the first few swipes of the clouds using the side of a No. 6 brush.

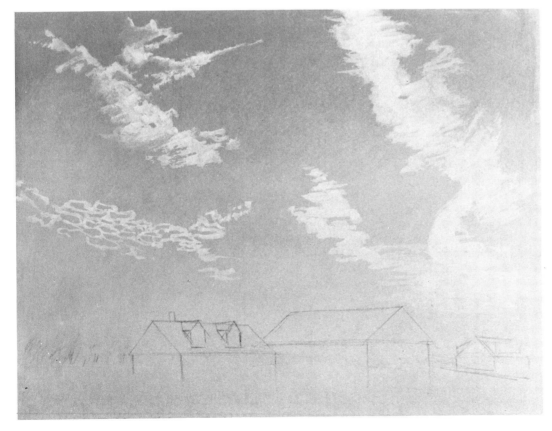

Step 2. I switch to a No. 2 brush because the larger brush was not giving me the lacy effect peculiar to cirrus clouds. I continue with the diluted white, by setting down the most interesting sections of the clouds first. Once these areas are established, I can easily join them to the main cloud formations. Please note that throughout the sketch I've diluted the white to a thin and medium consistency, going over the areas where I wanted brighter lights a second or third time instead of using the paint straight from the jar.

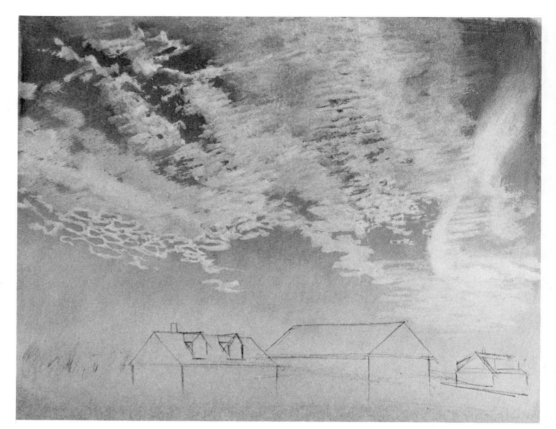

Step 3. Even though I dilute the white and continue to scrub with the side of the No. 2 brush, the gray of the sky doesn't mix with the white. Now I join the interesting portions of the cirrus clouds to the rest. The whole thing isn't exactly as it was when I began, but it's a convincing document of cirrus clouds, which is all I need.

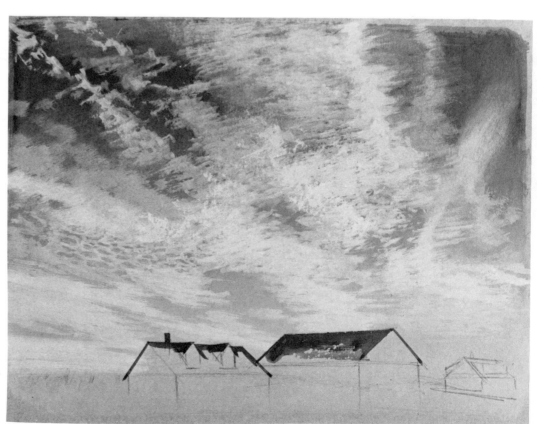

Step 4. Now I change to a No. 3 brush to paint the clouds in the lower part of the sky, running the white formations slightly into the contour of the cottages. I could stop here because I've got everything I want on the sky, but I carry on because I don't like to leave anything unfinished.

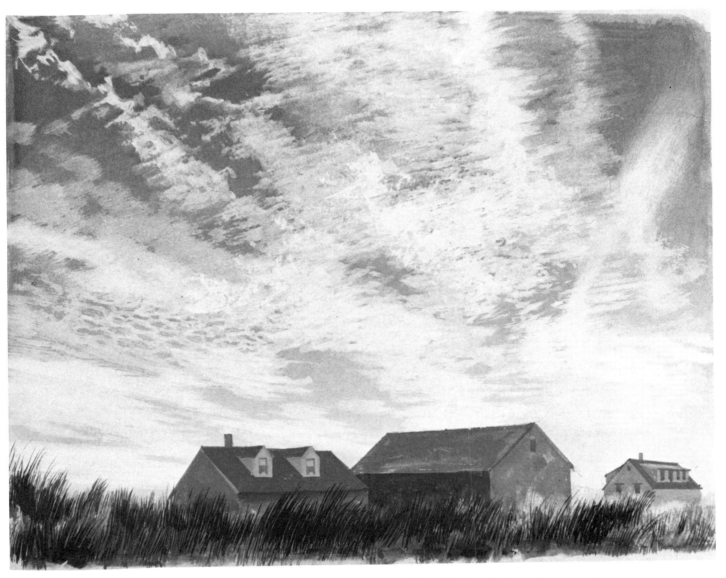

Step 5. With brushes Nos. 2 and 3 and grays Nos. 3 and 5 I finish the cottages and do the grass in upward flicks of the brush.

DEMONSTRATION 15.

Storm Clouds

It's been my misfortune to find myself in the most unfavorable conditions for painting whenever it storms. It either rains buckets so that I can't see out the studio window, or the downpour is so intense that it blurs the scene beyond the windows of my car. I really began to despair of ever catching on paper the drama of this exciting weather when, finally, while I was at my cottage at Sagamore Beach on Cape Cod Bay, the sky suddenly darkened. As if nature were trying to make amends for my past frustrations, she presented me with a magnificent spectacle. The clouds billowed and rolled and chased each other across the bay. I immediately set up my sketching things on the porch (shown in Demonstration 18) and finally got the stirring drama I'd been waiting for on paper, using these materials: the Morilla pad No. 1059-S, Gamma grays, black opaque, the No. 20 flat sable brush, and watercolor brushes Nos. 1, 5, 6, and 8.

Step 1. I notice that the lightest value in this stormy sky equals a No. 3 gray. So picking up the No. 20 flat sable brush, I load it fully and spread it as quickly as possible over the entire sky area. To get a flat, even tone, I brush in vertical, horizontal, and diagonal strokes without giving the edges a chance to dry. Next I dip a No. 6 brush into the No. 4 gray and cover the lower part of the picture to suggest the bay. The pattern you see is the texture of the paper itself.

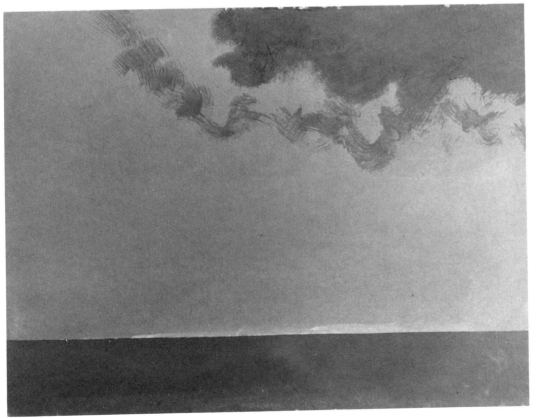

Step 2. Dipping into the Nos. 4 and 5 grays with the No. 8 brush, I scribble the shapes of the storm clouds as they fly across the sky. I'm not concerned with refinements at the moment—some edges are a bit hard, but there's no time to blend wet-in-wet or to drybrush them.

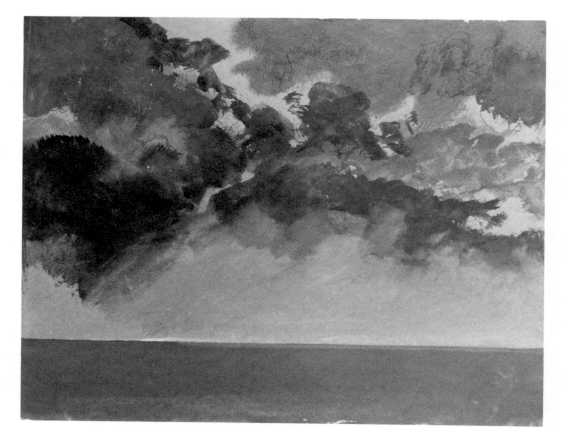

Step 3. Before it vanishes, I must get the lower portion of the main cloud bank. I continue using the same No. 8 brush and the Nos. 4 and 5 grays, holding the brush under the palm and quickly scrubbing away with its side, reaching for shape and value. I can see this is really going to be a very rough sketch; the clouds are racing by and their shapes change constantly.

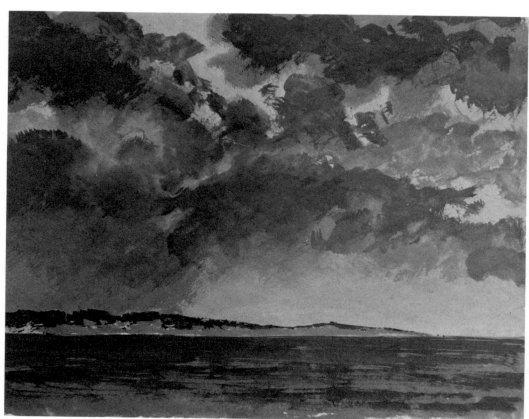

Step 4. I do the spit of land, still using the Nos. 4 and 5 grays but changing to a No. 5 brush. Then I sweep the brush across the bay in horizontal strokes to give it the aura of being stirred up so that it corresponds to the turmoil of the clouds.

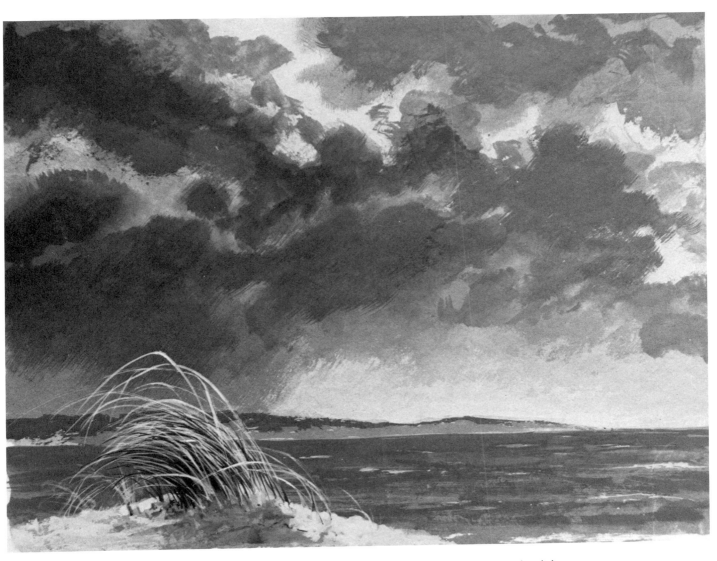

Step 5. With mixtures of No. 5 gray and black I darken certain areas, both because they got darker and also to make the scene more dramatic. By this time (about 20 minutes since I began) the horizon is lighter, so I brush on a No. 2 gray with the No. 6 brush. I then dip into the No. 1 gray with a No. 1 brush and sketch the white-caps. Finally I do the foreground grass to convey the great strength of the wind.

DEMONSTRATION 16.

Clouds at Sunset

This is one time when I took the chance of recording a fleeting condition—sunset—with the most capricious of media—aquarelle. As soon as I saw the sky this particular evening, I dashed downstairs (I was on the upper deck of the porch in Demonstration 18) and picked up a tube of Van Dyck brown, the Morilla pad, the water jar, and brush pot. Returning to the porch, I placed the pad against the railing and started to meet the challenge. When I reached for the paper towels, I realized I'd forgotten them, so—as it is my custom—I used my handkerchief. (I have in my possession, even after many launderings, the most colorful handkerchiefs in the world.) Anyway, let me show you how I did this sketch, with the materials mentioned, watercolor brushes Nos. 1, 3, and 6, and the No. 20 flat sable. I'll just add that I consulted this sketch when I painted Color Demonstration 4—it gave me a lot of valuable information.

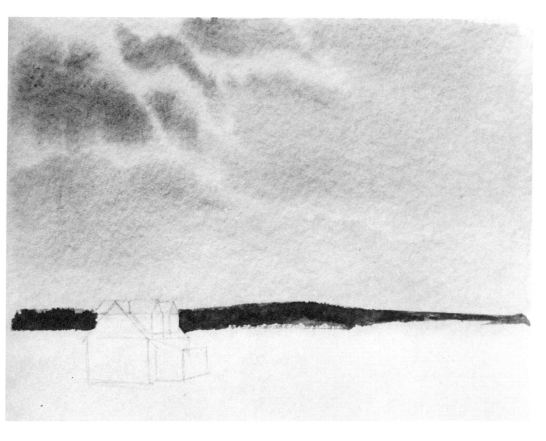

Step 1. I squeeze a ½″ of Van Dyck brown onto a large white plate. Then I wet the Morilla paper with the No. 20 flat sable brush. Touching the color with the edge of the brush, I work out a satisfactory tint on the plate and develop the first shapes on the sky while the surface of the paper is still wet in order to get the soft edges. This tint will be the foundation for the cloud formations that are to follow. The whites showing between the clouds are the paper itself. When the paper dries, I paint in the dark horizontal shape of the land with a No. 6 brush. I also outline a cottage (there are really three of them) on the foreground shore with the office pencil.

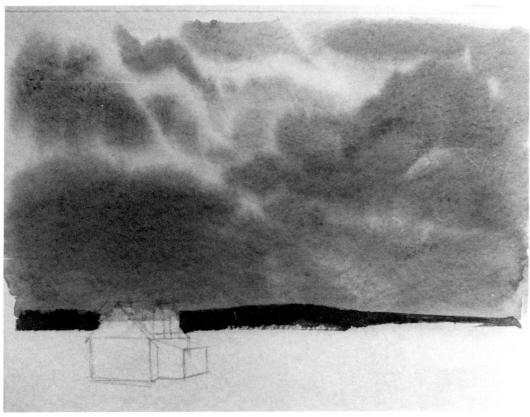

Step 2. Slipping a rubber band over the ends of the paper so the wind won't flap them, I wet the entire sky area again with the No. 20 flat sable brush. As you'll see when you do this, the shapes already established aren't disturbed in the least. Then, while the surface is still wet, I render the clouds in their middle value.

Step 3. When painting in a strong wind, the color dries instantly, so I have to wet the sky once more to accentuate the lower bank of clouds with deeper values. I also add some darker notes at upper left. By the time I finish these shadings—still using the No. 20 flat sable—the paper is dry again. At this point I enlarge the light spot of the sun and its diagonal rays with a kneaded eraser.

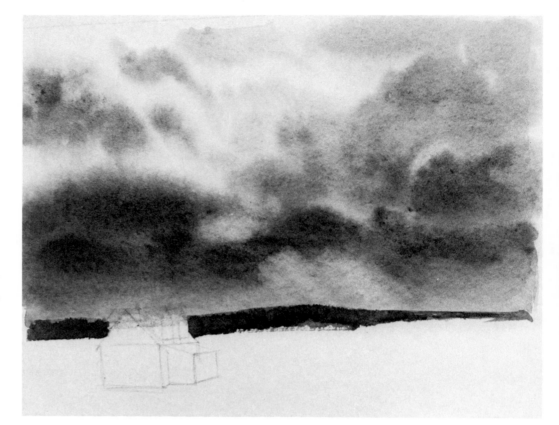

Step 4. This is the easiest step of all—I wet the space that's going to be the bay, and with the same No. 20 flat sable I float a light tint, leaving the paper untouched in some areas for the reflection of the sun.

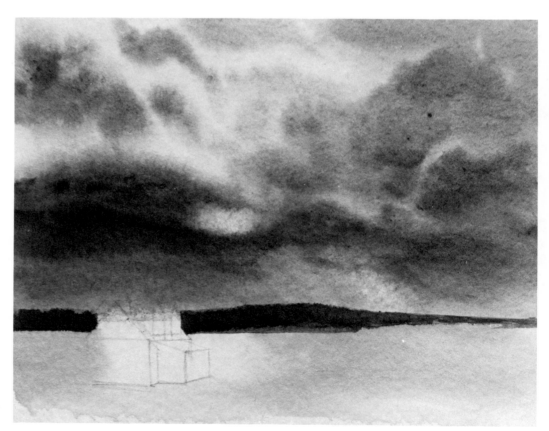

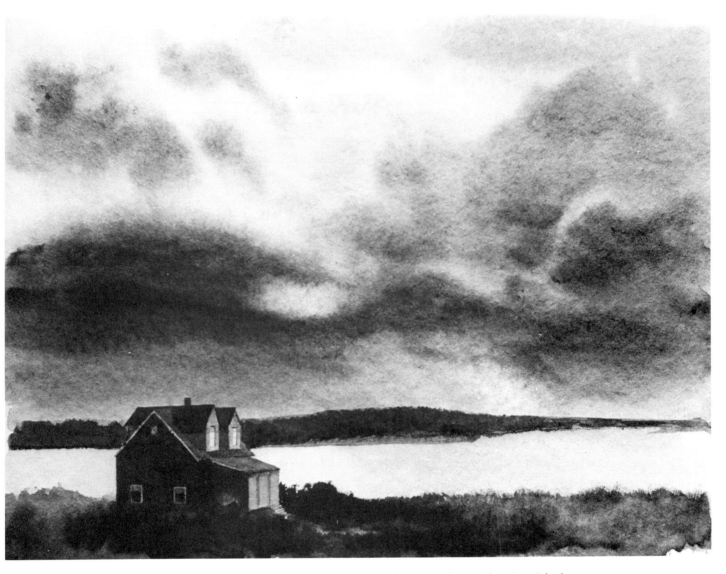

Step 5. Now I'm ready to do the cottage and the near shore. I begin with the cottage, using brushes Nos. 1 and 3 and the Van Dyck brown full strength, as well as diluted for light tints. Then I move to the foreground and, with the side of a No. 6 brush, I render the ground in a middle tone. While it's still wet, I dip into pure pigment and do the dark passages against the house.

DEMONSTRATION 17.

Mist

The main thing to remember about painting mist is that it pervades objects with an even tone (fog, on the other hand, has a tendency to be patchy). In other words, mist presents us with a picture that looks as though a veil were stretched evenly over the scene. I don't know why I love misty days. Perhaps it's because as nature throws her veils over the landscape, everything is cloaked in mystery—the most ramshackle hut is invested with pearly nuances and an opalescent beauty that raise it to a higher key. There are no ominous and gloomy darks or sharp contrasts, no jarring notes in the softly whispered poetry of mist.

For this sketch I used the Paper King pad, the Gamma grays plus black and white, the office pencil, a ruler, flat sable brushes Nos. 11 and 20, and watercolor brushes Nos. 1, 2, 3, and 5.

Step 1. I start by mixing equal amounts of Nos. 1 and 2 grays and applying the resulting tone to the sky with the No. 20 flat sable brush. Then, after indicating the shack on the wharf with an office pencil, I dip a No. 2 brush in the No. 2 gray and paint the outlines of the opposite shore and the shack at extreme left. I switch to a No. 11 flat sable brush and fill in those shapes—I fill in the shack at left evenly, but I leave some texture in the shore on the right.

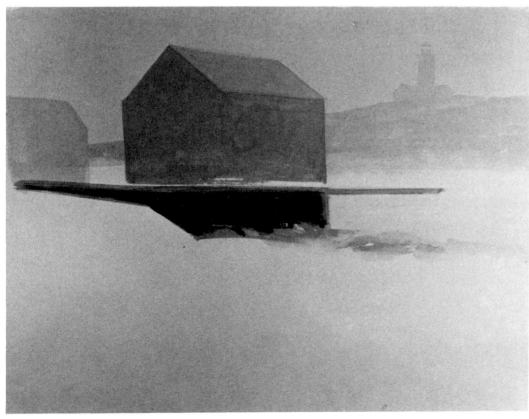

Step 2. Using the No. 11 flat sable I apply white with a touch of No. 1 gray to the water, working slightly into the opposite shore to soften the lower edge. Then I paint the shack on the wharf with a No. 2 gray for the roof and a No. 3 for its sides. Again I use the ruling method to get the straight edges (see Step 3 of Demonstration 12). Next I add No. 4 gray under the wharf, but I soon see that I've goofed—it dried much too dark. Note that the diagonals on the lower left are the beginning of a boat.

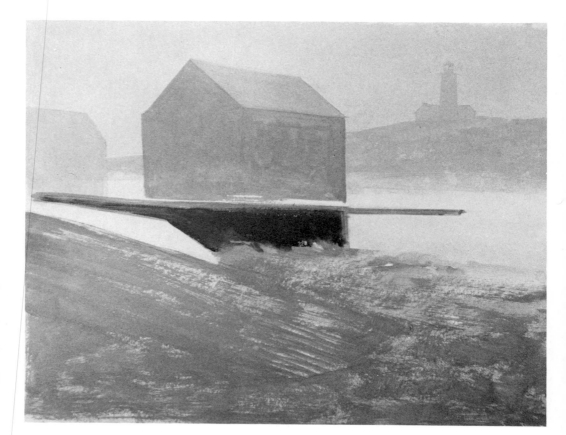

Step 3. I scrub the side of the No. 11 flat sable brush in the foreground with a No. 2 gray, following it up with a No. 3 gray on top to get the texture. I like the simplicity of the composition, and at this point I wonder if I should include the boat I've faintly indicated projecting diagonally from the left.

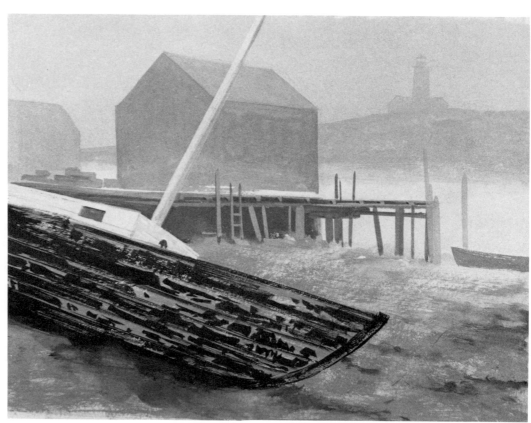

Step 4. As you see, I can't resist old boats and their peeling hulls, so I paint it in with the No. 5 gray and a smidgen of black under the keel. Then I lighten up the tone under the wharf by scrubbing a thin No. 3 gray over the No. 4. Next I do the ladder and stanchions—beams under the wharf—with mixtures of Nos. 1, 2, and 3 grays. Moving over to the boat's white cabin, I trim it with white using a No. 2 brush. I do the mast with white and a touch of No. 3 gray and the boat at right.

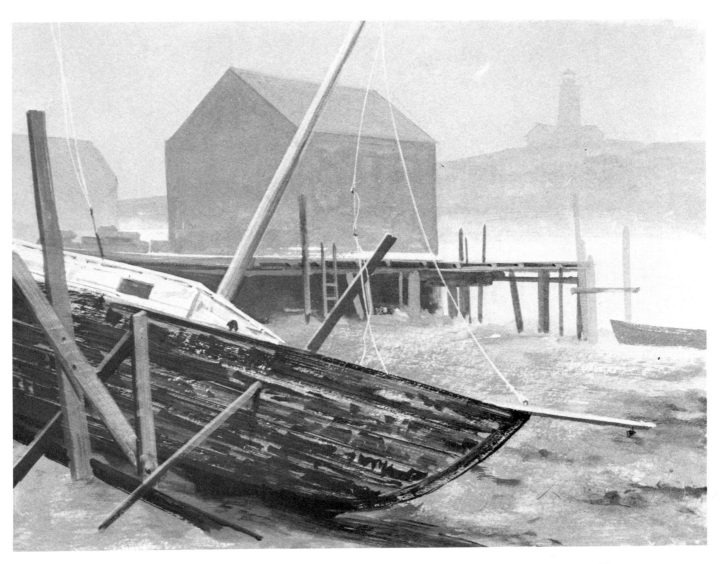

Step 5. I indicate the paint peeling off on the cabin wall with a No. 2 brush dipped in grays Nos. 1 and 2. Then I run a No. 3 brush over the hull with a very diluted No. 4 gray to subdue the busy pattern of that peeling paint. Finally I paint the ship's cradle in Nos. 4 and 5 grays; and with a No. 1 brush and white I add the few remaining lines of the rigging.

DEMONSTRATION 18.

Rain Falling

Rain is akin to mist and fog in its tendency to soften the landscape—in varying degrees, of course, depending on its gentleness or its fury. Rain also makes things glisten and sparkle. However, it goes without saying that painting in the rain is out of the question. I've tried painting from the car in the rain, but I've had nothing but total failures. I've also attempted to paint through the studio window with an occasional measure of success. But it was not until I painted from the porch where I sketched the storm in Demonstration 15 that the picture turned out well.

For this demonstration I did a drawing of the view beforehand and put it away, waiting for an effect that might be too transitory to sketch without previous preparation. (I do this whenever possible.) Let me show you how I tackled the problem, using heavy-weight Strathmore paper, India ink, Gamma grays, black and white, the office pencil, a ruler, a white Conté pencil, flat sable brushes Nos. 12 and 20, and watercolor brushes Nos. 1, 2, and 6.

Step 1. It was a sunny day when I drew this scene in pencil and then reinforced it in India ink with a No. 1 brush to prevent the lines from being covered with the opaque watercolor I plan to use. The rainy day has finally come—I take out the drawing and wet the sky area with the No. 20 flat sable brush. While that area is still wet, I begin painting Nos. 2 and 3 grays and white with a No. 6 brush. Note that the pencil lines of the cottages in the distance—which I didn't trace with ink—are almost lost. I bring back their silhouette with the No. 2 brush and the No. 2 gray.

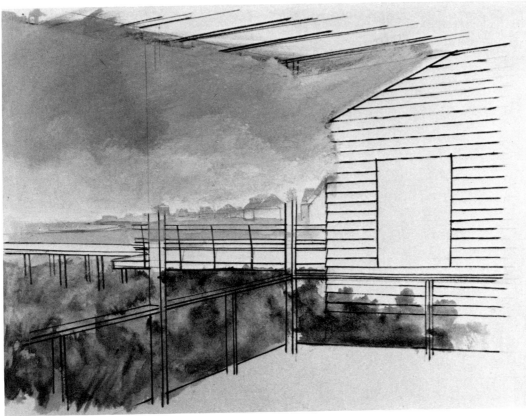

Step 2. I paint the ground beyond the deck with the No. 2 gray. Then I pick up the No. 12 flat sable, and with a very diluted No. 4 gray I float the variegated tone between the deck and the floor of the porch. Notice that the indelible ink isn't disturbed as I rub the pigment over it—the lines remain clearly visible.

Step 3. The No. 6 brush loaded with a mixture of No. 5 gray and black comes into play when I paint the roof of the porch and when I deepen and describe the foilage of the dune roses between the deck and the porch. Then I float a thin coat of No. 5 gray with the same brush over the shingled wall—so thin that, as you can see, it runs and doesn't cover the light grays of the sky I'd overlapped.

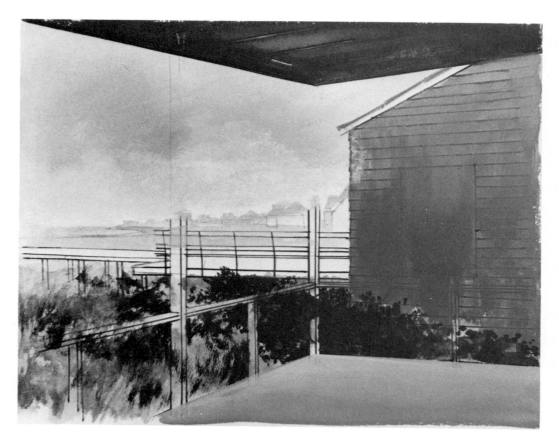

Step 4. It's time to finish off the background and the bench on the deck so I can do the poles supporting the upper deck of the porch in the foreground. Working from the back forward, I do the bay, the deck, and the bench with grays Nos. 1, 3, and 5. Then I do the poles of the porch over everything else using the ruling method.

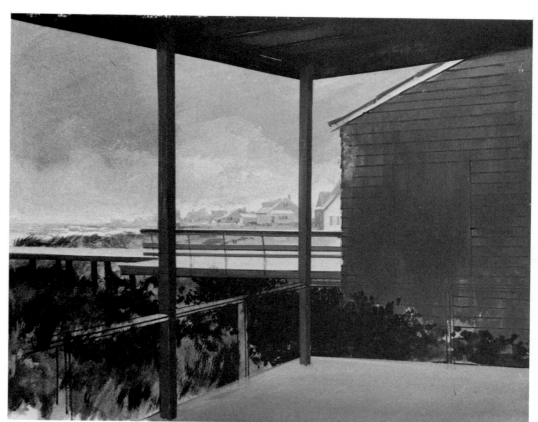

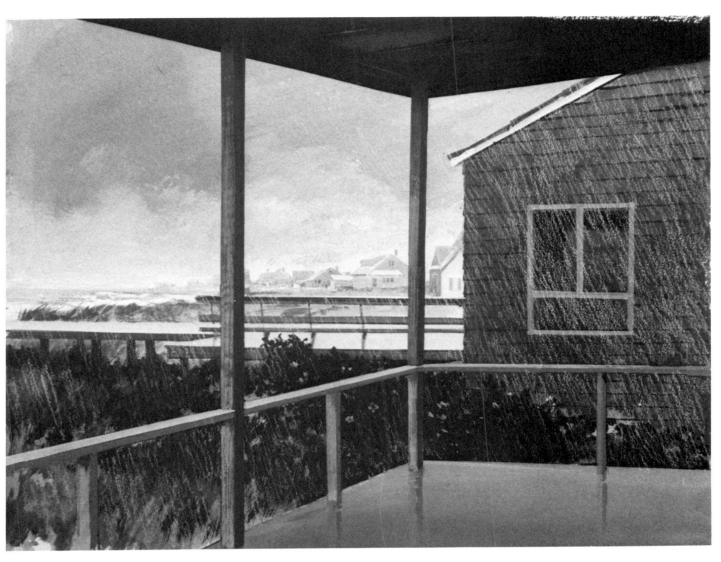

Step 5. Here I highlight the dune roses with a No. 1 brush and the No. 1 gray. Then I add the window with a No. 3 brush and the No. 2 gray, followed by the railing and its reflections with Nos. 1 and 4 grays. I patch the light spot at the corner of the wall and the gable with the No. 5 gray. Finally, with a white Conté pencil, I do the light lines suggesting the rain—the pencil renders its character better than brush and pigment.

DEMONSTRATION 19.

Snow Falling

I need hardly mention that I had to wait for the meteorological phenomena in the past two sketches. The sun may not shine every day, but neither is it foggy, misty, or rainy all the time. As for snow, well, even in New England I had to pray for it. And then, it came—in bushel baskets—to the point where I thought I'd never want to see any more. I knew that thought wasn't really true—I doubt there's an artist anywhere who can resist nature's charm when she dons her white mantle. The most convenient way to record an effect like this is with the camera, as I suggested in my last book, *Creative Painting from Photographs.* There are times, however, when I feel that I just have to recharge my batteries with direct contact with nature. So I got in the car, first making sure that I had a No. 14 bristle brush because without it I couldn't have done the snow, as you'll see. The other materials were white pebbled matboard, Gamma grays and white, an office pencil, a No. 12 flat sable brush, and watercolor brushes Nos. 1, 2, 5, and 6. Please note that as I was working with very close values, I jotted down notes in the margin of the paper describing the percentage of the mixtures I used for possible changes or later corrections.

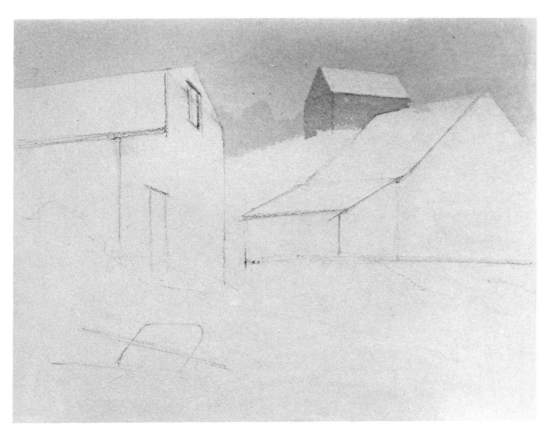

Step 1. First, very simply, I rough in the houses with an office pencil—for placement and composition rather than for correct construction. Next, I mix equal portions of Nos. 1 and 2 grays and paint the sky with a No. 6 brush. Using a No. 5 brush, I paint the silhouette of the trees in the background with the No. 2 gray. Then I do the barn with a half-and-half mixture of Nos. 2 and 3 grays.

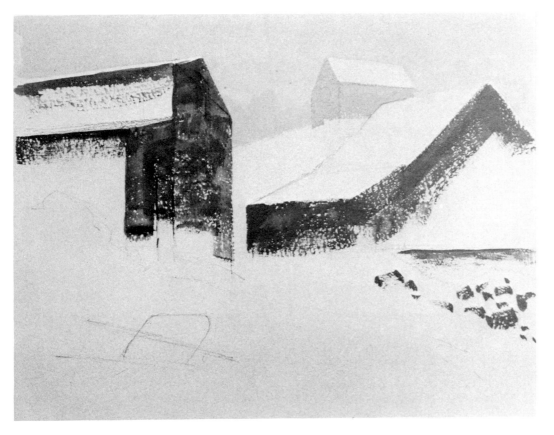

Step 2. The No. 12 flat sable brush comes into play here as I do the buildings with No. 4 gray as fast as possible—I brush in quick strokes to let the pebbled surface of the board play its part as falling snow. Then with the side of the No. 6 brush I scumble the stone wall. I can't repeat too often that you must dilute these grays—they're hard to use when they're too thick.

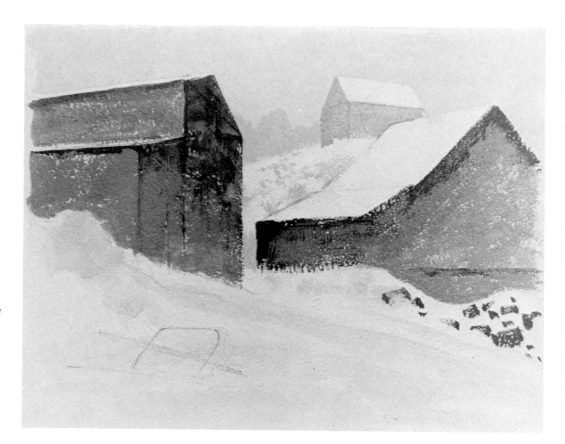

Step 3. I complete the shapes of the houses with a No. 3 gray, still using the No. 12 flat sable. I dip next into the No. 2 gray with the No. 2 brush and scrub its side on the middle hill to suggest some vegetation. Then I pick up the No. 12 flat sable again and with very thin No. 2 gray I indicate the snowdrifts in the foreground.

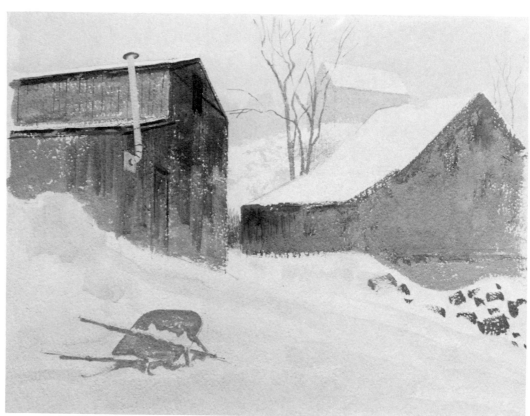

Step 4. Now that I have set the big shapes down, I can move on to the smaller elements such as the tree, the chimney, and the wheelbarrow. I also rough in the window, the door, and some boards on the building at left. For all this I use the No. 2 brush and grays Nos. 1, 3, 4, and 5.

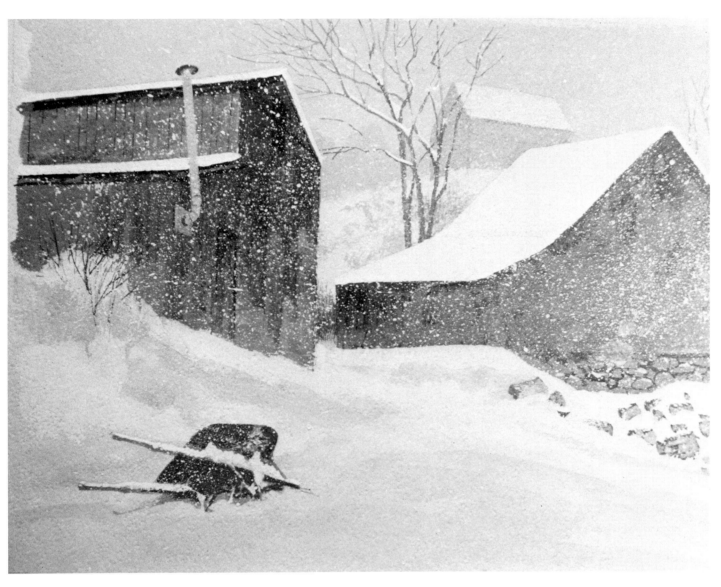

Step 5. Here I deepen the tone of the wheelbarrow and introduce the bush on the left. Then I finish the tree and decorate it with snow. As I work on the stone wall at right, it becomes a bit too insistent so I subdue it with a thin No. 2 gray. Now the time has come to dip the No. 14 flat bristle brush into the jar of white, dilute it a bit on the tray, and, with my forefinger, riffle the bristles close to the board. I begin on the left of the picture and work my way to the right. The dots that strike the board give me the effect of falling snow in minutes—try it!

COMPLETE PAINTINGS IN COLOR

The time has come to put to work the stuff plundered from nature. Isolated sketches, charming as they may be, are one thing, but a painting bristling with problems of unification is quite another. I wish all considerations dealing with picture-making would resolve themselves and leave us free to just pull or push a brush. But it is written that by the sweat of our brow, etc., etc. So be it. In the demonstrations that follow I'll show you how to use the loot gathered from life and apply it to a painting. This of course requires a bit of feeling as well as a spot of thinking. I've been given an adequate amount of the first, but I find the latter a most painful process. May you be endowed with a generous portion of both.

The execution of the paintings that follow is described in four steps, but let me emphasize that the preliminary work for each painting consisted of a preparatory sketch to solve problems of composition, tone, and color, and a pencil line drawing enlarged from the sketch using my squaring-up method (dividing the object or scene to be drawn into a grid and transposing it onto a proportionately larger grid). I did every drawing on tracing paper so that I could easily transfer the image to the support of my choice. I must say again that an object may be marvelous in itself, but only when that object can function with other elements is it worth being seriously considered for the painter's purpose. To use and arrange bits and pieces, to create a stirring affirmation, is the aim of this book. Now let's get to work, because *the only way to learn to paint is by painting.*

Color Demonstration 1. Trees and Grasses

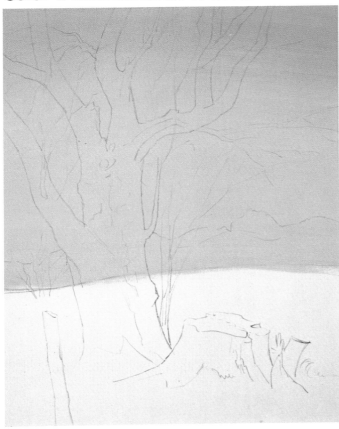
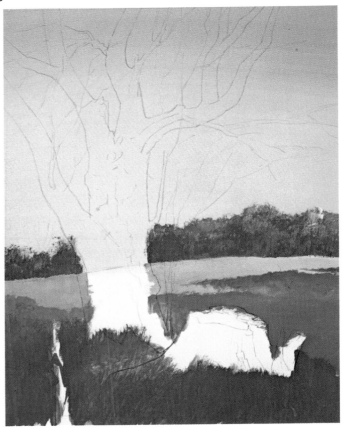

Step 1. The only thing I trace from the working drawing to the double-thick Bainbridge illustration board No. 80 is the horizon line, so I'll know where to stop the sky. I squeeze a sponge over the Pelikan color cakes so they'll be moist when I begin to paint. Then I pour some Rich Art white onto the butcher's tray and thin it with clear water, using a No. 22 flat sable brush. After rinsing this brush, I transfer puddles of sienna, yellow ochre, and cobalt blue to the tray. With a smaller brush, I work some of the blue into a generous amount of white and temper the resulting blue tint with a spot of sienna to warm it up. Beginning at the top, I apply a thin wash with the No. 22 flat sable in broad, horizontal strokes. My brushstrokes extend about an inch past the borders of the picture. Working my way down, I dip into more white and the yellow ochre and blend wet-in-wet. I add still more white as I near the horizon to get the gradated effect of the clear sky in Demonstration 12. After the paint is dry, I trace the trunk and limbs and other important elements over the sky.

Step 2. I consult the preparatory sketch, and with the side of a No. 5 brush scantily charged with combinations of ultramarine blue, raw umber, orange, and white, I scumble the band of trees while holding the brush under the palm. I keep the light angle in mind and introduce lights and shadows to give the mass a sense of form. Next, using white, burnt sienna, yellow ochre, and French green, I tap and drag a No. 11 flat sable brush vertically on the light areas of the grass. Then I do the shadow areas with a No. 5 brush, using Indian red, yellow ochre, and cobalt blue, letting the last color dominate to make the shadows cool against the warm sunlit areas. As I work my way to the foreground, I add more color and less white to deepen the value. I mix the shades and tints on the tray as I proceed, to get "broken color," a heritage from the Impressionists in which individual hues, not thoroughly mixed, produce a vibrant passage rather than the dead coat of paint that results from using a previously stirred batch. Since the star of the show is coming up next—the tree—I place my sketch from Demonstration 3 close by.

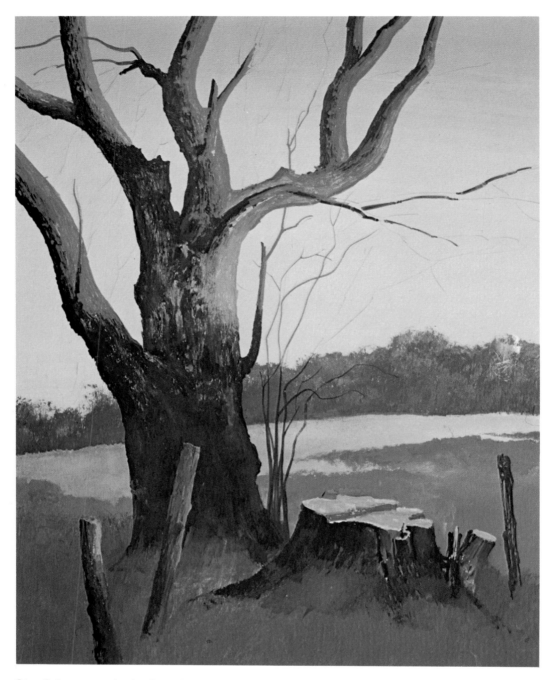

Step 3. I suggest the bark of the tree, using the side, heel, and tip of a No. 3 brush dipped into thin mixtures of ultramarine blue and Indian red. First I do the shadows on the trunk and branches. Then, adding white, orange, and French green to that mixture, I do the light areas, overlapping them slightly into the shadows to soften the edges and create the basic cylindrical forms. Next, consulting Demonstration 4, I indicate the stump at the base of the tree with the same colors and the same brush as those in that demonstration. At this point, I'm not satisfied with the composition—I place a piece of acetate over the painting and tentatively introduce the other two posts. This is much better, as the posts increase the depth of the picture. I remove the acetate, paint them in, and then indicate the bush by the trunk.

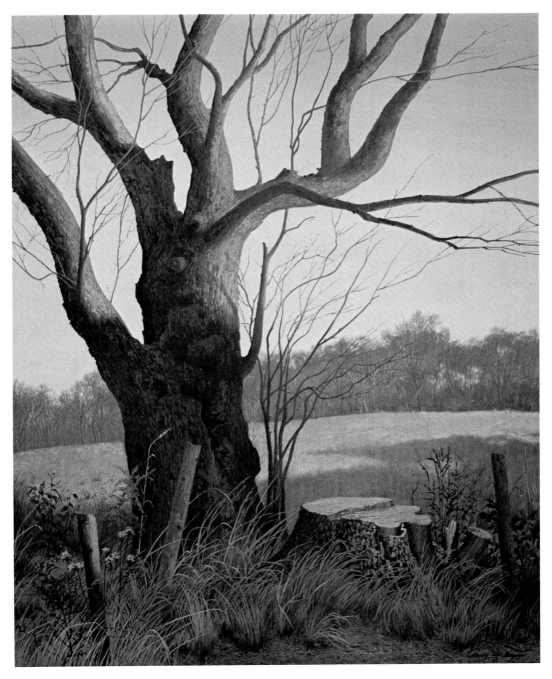

Step 4. With the same colors but thicker paint, I work my way from the back forward. Tackling the band of trees with my hand on a mahlstick and using a No. 1 brush, I render the top edge, sweeping the point of the brush upward and with left and right diagonals into the sky. Then I glaze and scumble with ultramarine blue, raw umber, orange, and white, dimming the sunlit areas and showing bits of sky. Then, using brushes Nos. 1 and 2, I do the trunk, the limbs, the branches, and the twigs. I define the grass with a fanned No. 3 brush, stroking down to get the short grass effect with orange, blue-green, Indian yellow, and white. I move to the shadows on the grass and do them with the same brush and green deep, orange, and black. Now consulting the sketch from Demonstration 5, I distribute the weeds with a No. 1 brush, contrasting dark against light and light against dark.

Color Demonstration 2. Dunes

Step 1. First I trace my working drawing and pin it up, along wth the preliminary sketch and the sketches from Demonstrations 11 and 14. Then I trace the drawing again, onto a 15" x 20" sheet of Fabriano watercolor paper. To minimize the paper's buckling when wet, I secure it to a drawing board with masking tape along the four edges. By varying the tilt of the board, I can control the flow (speed and direction) of the wash.

I squeeze a sponge over the color cakes in the Brilliant watercolor set No. 30-25 by Grumbacher which I decided to use. In a cup I prepare a tint of blue I and clear water. I test it on the margin of the paper, because watercolor dries lighter. Then with a No. 7 brush I wet only the edges I want soft, and while the water still glistens I apply the color with a No. 5 brush. When I'm satisfied with the pattern made by the blues at the top of the sky, I mix another tint with blue II for its lower part, and follow the same procedure. After the sky is dry, I shade the clouds with a tint of Payne's gray (from a tube because the Brilliant box doesn't carry it) and red II to give them a sense of form.

Step 2. I prepare the tint for the dunes with raw umber and Payne's gray. After testing the tone on the edge of the paper to verify its color and value, I tilt the drawing board to about 45°. Beginning at the top, on the dry surface of the paper, I follow the contour of the dunes with a fully charged No. 22 flat sable brush and then change to straight horizontal strokes as soon as I can. Recharging the brush generously, I bring the wash down in back-and-forth strokes, going past the borders of the picture. I make sure that the top edge of a stroke merges with the bottom edge of the preceding one to give me the flat, even tone that I need. Remember that the tilt of the board will allow the color to spread downward at the right speed. If the angle is too steep, the wash will drip past the edge of the stroke; if it's too flat, the wash will spread upward and blotch the even tone required here for the modeling coming up in the next step. Just one more tip: when working during an extraordinarily humid day, the drying period of a large wash can be expedited by using a hair dryer.

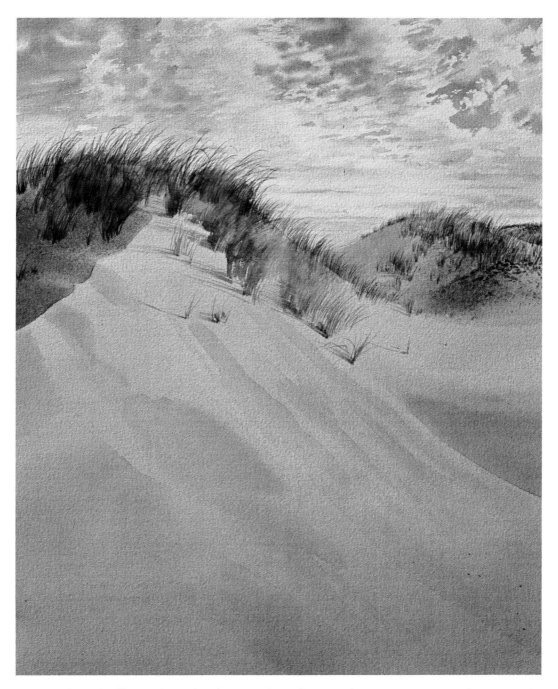

Step 3. When the flat wash on the dunes is dry, I dip into the mixture previously prepared for them, pull a puddle onto the butcher tray, and add more raw umber and Payne's gray to deepen the tone. I dampen the edges that I want soft and leave the surface dry where I want them firm. Remember that in this medium you can wet certain painted areas without disturbing the color already applied. You can also float another wash over one already dry to deepen or to modify a color. In this way, I do the modeling on the dunes with a No. 7 brush. Then with a No. 1 brush and green II, yellow green II, and a touch of brown light, I do the grass in upward strokes, using a mahlstick. Before adding the last touches, let me stress this point: the paper itself must be retained for all the whites. Introducing white pigment is tantamount to an admission of incompetence in handling this medium.

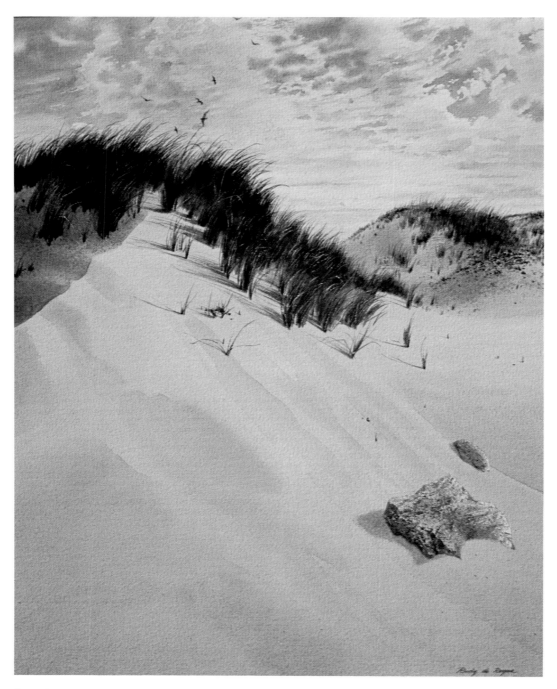

Step 4. I make the grass shapes bolder, with stronger intensities of green II and brown light—letting the latter color dominate because it works better against the cool sky. As the darker tone weakens the shadows on the dunes, I give them another wash of blue II and red I added to the color of the dunes mixed earlier. Also, I notice that the triangular shape on the right is too dark, so I lighten it by rubbing gently with a kneaded eraser. I introduce the gulls next, because as I mentioned in Demonstration 11, I want to engage as many of the spectator's senses as possible. Next I put in the rocks first with pencil and then with a sponge dipped in red I and blue II. I scratch out the lights with a razor blade and give the rock form and configurations using a No. 1 brush. I move over to the smaller rock and add form with the brush alone.

Color Demonstration 3. Snowscape

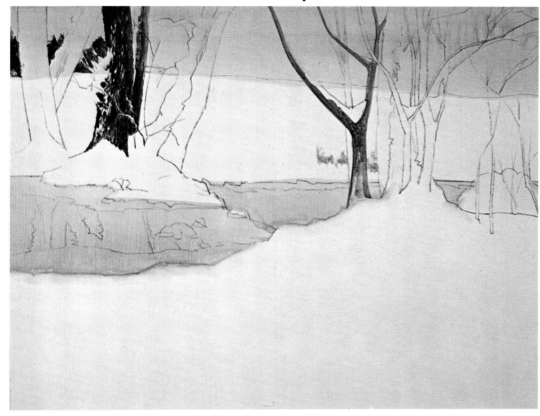

Step 1. I trace the main elements of the working drawing to a 15" x 20" Bainbridge board No. 80 coated with Liquitex gesso dried overnight. I mix three egg tempera colors—alizarin crimson, yellow ochre, and phthalocyanine blue—in nesting cups. Then I transfer a spot of each color onto the butcher's tray with the No. 20 flat sable brush and add enough water to mix a bluish gray tint. I float a wash on the sky and over the stream in horizontal back-and-forth strokes. Next, I do the evergreens with a No. 3 brush and mixed green. I set down the dark foundation of the tree trunks with all three colors but without water. Then I introduce a bit of grass with a No. 1 brush and yellow ochre, a touch of crimson, and a whisper of phthalo blue.

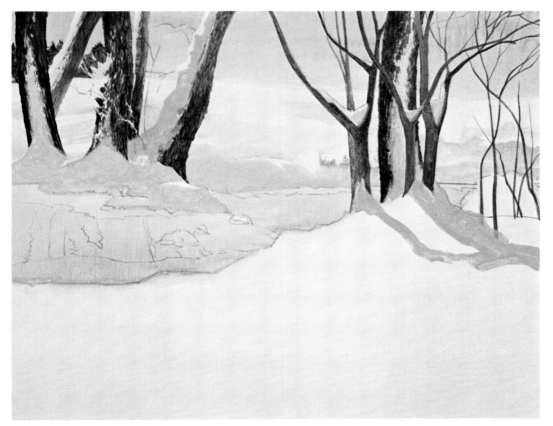

Step 2. I continue with the rest of the trees using thin paint and the No. 3 brush. I suggest the bark to be articulated later, but I take care to distribute cool and warm trunks—the main verticals and diagonals—as I set them down across the painting. Then I prepare a batch of white, transfer some of it to the tray with a No. 5 brush, tint it with the three colors to make a cool gray, and apply it to the shadows in the snow. When this is dry, I glaze it with tints of crimson, yellow, and blue to bring out reflections. I keep in mind the old dictum that outdoors the lights are warm because of the sun and the shadows are cool because they reflect the sky.

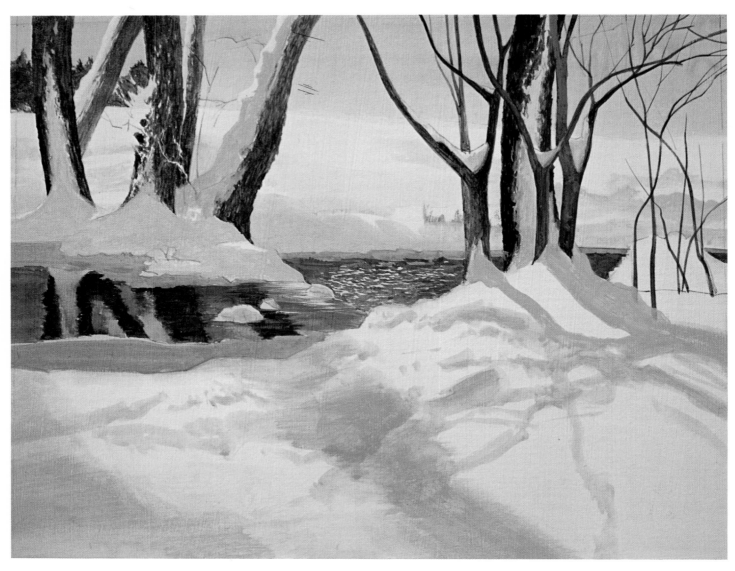

Step 3. The horizontal of the stream now supports the verticals and diagonals of the trees and pulls them together to form the main unit of the painting. I'm still using washes mixed in the tray, where I can shape the No. 3 brush—pointed or flattened—to execute an edge or paint a tone. When I finish a painting session, I wash the cups that have been depleted, and cover those still containing pigment and place them in the refrigerator so the egg won't spoil. So far I've dipped into the white only to prepare the undercolor for the shadows on the snow. Next, I mix the color for the stream and glaze it with a No. 7 brush. The sparkle on the water is the bare gesso, but the whites in midstream have been repainted. And then, using body color, I indicate the ice beginning to form on the banks. I continue to articulate the cast shadows in the foreground, sometimes following the sketch or the demonstrations I pinned up—Nos. 2, 21, and 24—and sometimes disregarding them striving for a pattern that functions with the shapes already established. I keep an eye on the combination of the small shadows on the snow with the broad diagonal shadows cast by the trees. The shadow in the lower left is beginning to disburb me, but I'd like to keep it to suggest that, even though not seen, there are other trees beyond the picture border.

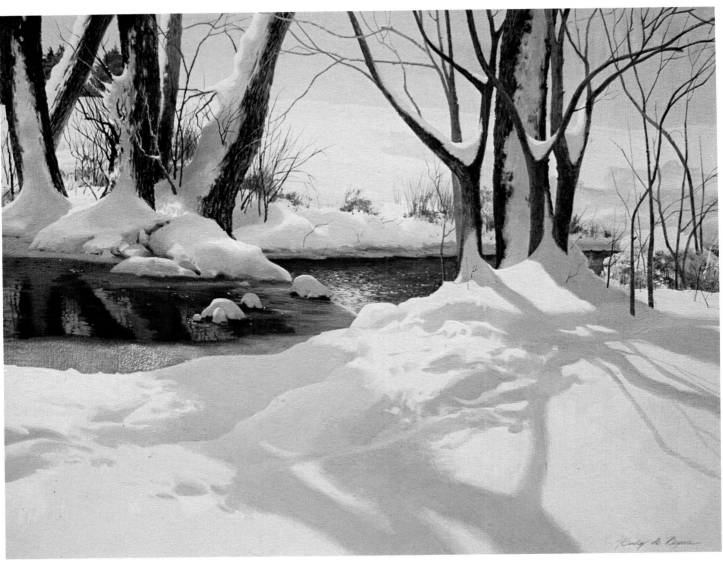

Step 4. With as thick a mixture of gray as I can get with this medium, I tap a sponge on the ice. The resulting texture is hardly visible, but I'll bring it out by scumbling lighter color over it with a scantily charged No. 3 brush. I give a glaze of yellow ochre to the stream because, stepping back, I notice it's too blue. I move over to the shadows in the foreground and refine their shapes but decide to eliminate the shadow on the left. Even though I like what it suggests, it doesn't come off visually. To compensate for it, I give the remaining cast shadows wider and more interesting shapes; of course, I make sure they also still conform logically to their source. I extend the pattern of small shapes to complement the long diagonals of the adjoining shadows. Next, I pick up the No. 1 brush; using its side and letting the yellow dominate the crimson and blue, I do the weeds and grass and stipple the bush on the right edge of the picture. I add the slim branches on the trees and their shadows on the ground. I refine details on the snow banks and wherever they're required as I scrutinize the picture up close and from a distance. My approach to painting is to work out a composition and color scheme that is appealing from across the room, but also delights the eye with meticulous detail at a closer range.

Color Demonstration 4. Clouds at Sunset

Step 1. Let's follow up with another egg tempera to demonstrate that there's no set rule or rigid procedure in painting, even when using the same medium. First I pin the preparatory sketch for this painting and Demonstration 16 on the wall. I trace the drawing on a 15" x 20" Bainbridge illustration board No. 80 in India ink—I want the buildings to remain indelible in case I have to remove a passage in paint by sponging off the water-soluble egg tempera. Then I do the linear construction of the buildings with a No. 1 brush and ink straight from the bottle, using the ruling method. Then, with the tip, side, and heel of a No. 3 brush, I begin applying the grays, diluting the ink with water on the tray, leaving room at the bottom of the painting for a boardwalk.

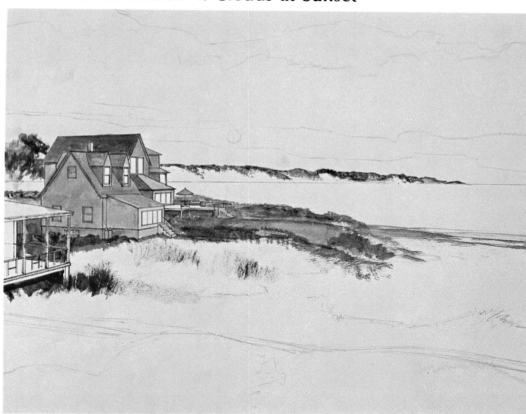

Step 2. I prepare alizarin crimson, yellow ochre, and phthalocyanine blue in three nesting cups and apply very thin washes all over with flat sable brushes Nos. 11 and 20. I make sure that the pigment gets a generous amount of the egg medium so that the binding vehicle remains strong, even when I add large amounts of water. I wet an area on the board where I want soft edges; I work on the dry surface for a firm silhouette. I apply the washes quickly to cover the white ground so that I can better judge the darkness or lightness of values that come next. If bits of skin from a former painting session intermingle with new mixtures, I wet the tray with a paper towel and scrape off the mess with a razor blade.

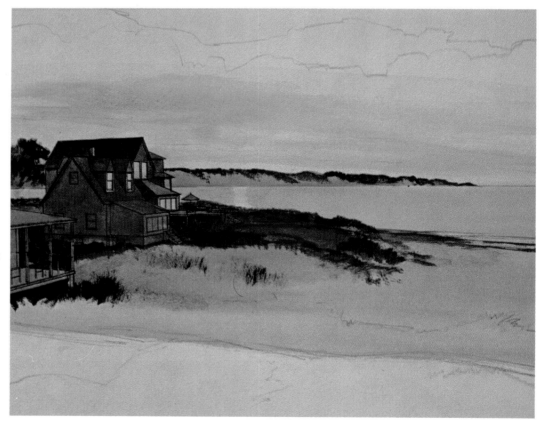

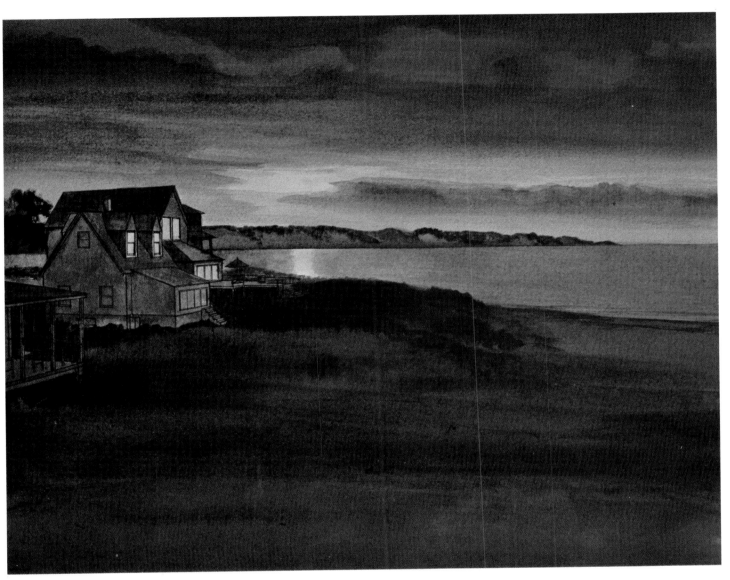

Step 3. I continue the washes over the entire picture with flat sables but change to a No. 7 brush for the smaller areas. I use thicker pigment where I want dark notes, such as on the grass. The mixture for the darkest darks consists of crimson and blue, which gives me either a blue- or a red-violet. Proper shades, I think, to herald the approaching darkness; but if they become too vivid, I glaze them immediately with yellow ochre to neutralize them. Notice that even though I've applied repeated washes over the buildings, their linear structure still shows clearly. Also, the thin washes of color over the white paper give me the luminosity required in a scene like this.

I now have the approximate color and tonal scheme of the preparatory sketch, the whole thing done without yet touching white pigment. I step back to appraise the painting's color and tonality better, and I realize that in spite of my efforts to subdue color intensity, the whole thing is much too purple. Quite a problem in another medium, but here it's easily solved by floating a yellow ochre wash over the entire picture with a No. 22 flat sable brush. (You can always use a complementary color to lower an intensity—glaze a too-bright red with green to mute it, for instance.)

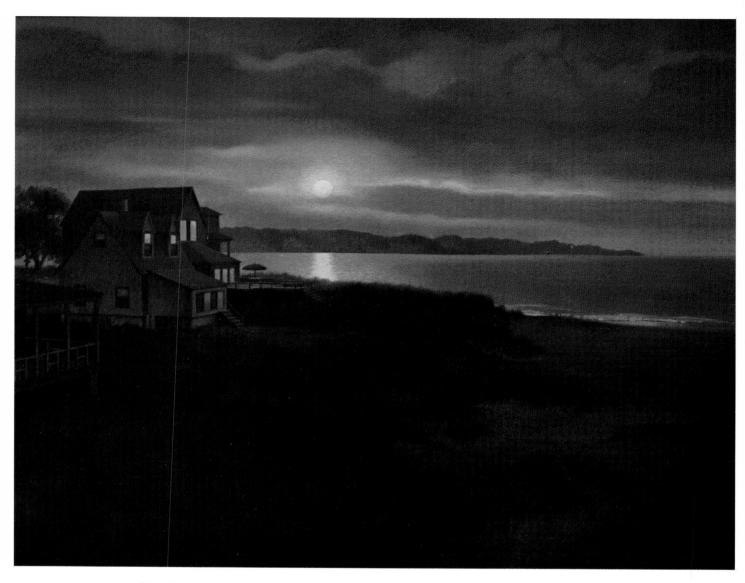

Step 4. I continue glazing the buildings—but not the windows—with Nos. 3 and 5 brushes, using warm and cool color. I move to the ground, and with a No. 20 flat sable I deepen the values in some horizontal but mostly vertical strokes to begin suggesting the grass that I'll define later. After doing away with the boardwalk—its horizontal detracts from the sky—the darker ground tone makes the water appear too light, so I darken it with a No. 7 brush. Moving back to the buildings, I carry them as far as I can with Nos. 1 and 2 brushes, adding white pigment to get the beautiful quality of paint inherent in this medium. Then, with all three colors and the white, I render the sky with fanned brushes Nos. 3 and 5, applying the color in diagonal strokes. Sometimes I crosshatch them for greater density of pigment and better covering power, working with a mahlstick for freer sweeps of the brush to soft-blend one tone into another. Finishing, I paint the sky slightly into the promontory and over the tree. Later I redo the silhouette of the roofs, render the decks and the porch at the left, and go on to add other minor details, with brushes Nos. 1, 2, and 3 and using the ruling method on all straight edges. I finish the grass with upward strokes of a No. 1 brush, tickle the foliage on the tree, glaze the surf, and there we are—with another magic realist painting in our hands!

Color Demonstration 5. Country Scene with a Dirt Road

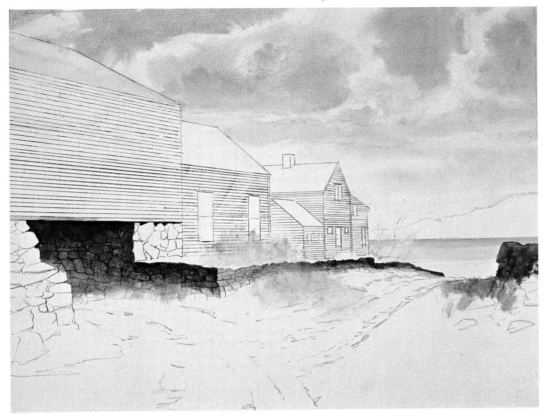

Step 1. First, I transfer my working drawing to the Bainbridge board No. 80 with a pencil. I moisten the blue II of the Brilliant watercolor box No. 30-25, dilute it on the tray, and add a whisper of brown light and more water. I wet the edges of the picture I want soft with a No. 7 brush and quickly apply the color so it spreads into them. Then I add more water and a touch of yellow ochre to the paint, and wetting the required edges, I do the lower part of the sky. When the patches of blue are dry, I wet the contour of the cloud at upper left and apply a mixture of Payne's gray and brown light. I work my way to the right, diluting the color for the lighter passages. With black and purple, I introduce some darks on the ground, as well as a mixture of orange I and yellow ochre, the warmest spot.

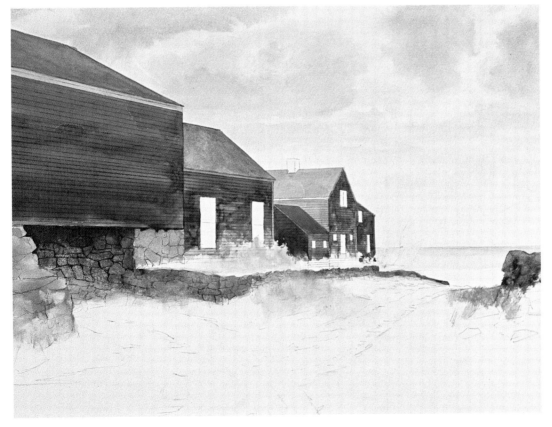

Step 2. I apply a mixture of Payne's gray and brown light to the buildings with a No. 5 and a No. 7 brush, trying not to float an even tone because I want the blotchy and weathered effect from the very beginning. As I lay down this large dark area, I keep an eye on how it balances the light ones already established in the sky. Next I remove the line of the hill jutting out from the right with a kneaded eraser because it's too high. The demonstrations I refer to here are Nos. 5, 13, 25, and 29—modified and arranged to create a verisimilar pictorial statement. This approach to picture-making gives you the greatest freedom to invent a scene which, although existing nowhere, can still delight the spectator.

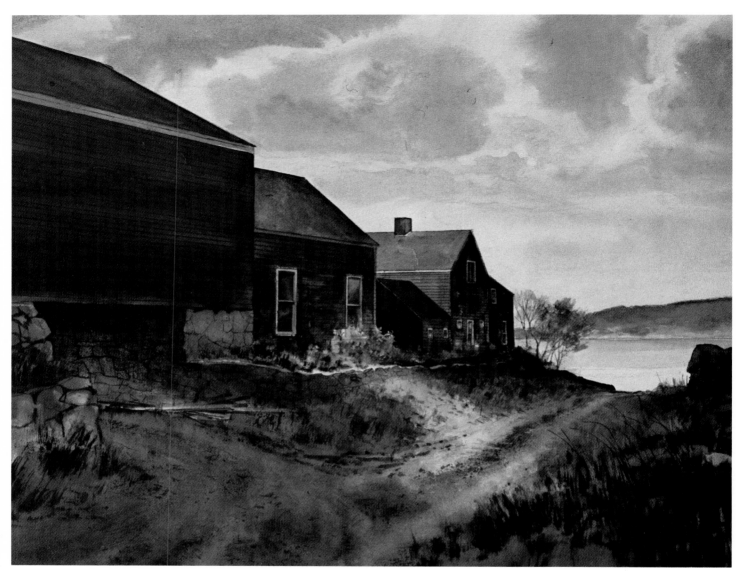

Step 3. Applying the same color mixture used for the buildings, I do the grass and the road configurations using the point, side, and heel of a No. 3 brush. Then, studying Demonstration 29, I tap a synthetic sponge between the wheel marks for still more texture. This is followed by large washes with a No. 9 brush over the entire ground, letting the Payne's gray or the brown light dominate for cool or warm nuances. With the same mixture but adding more water, I do the hill in the distance. Then I move to the chimney and do it with mostly the brown, tempered with the gray. Next, with a scantily charged No. 2 brush I do the foliage on the tree and indicate broadly the bushes under the window. The picture at this stage is complete, even if unfinished. Many artists would stop here because the desired effect has been captured, but what moves me to paint is both a need to seize a mood *and* to loot as much of nature's bounty of beautiful detail as I possibly can.

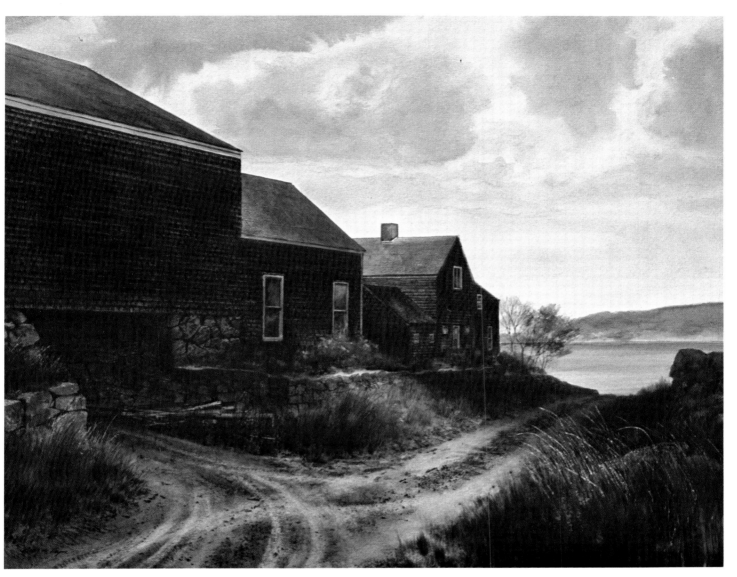

Step 4. I scratch the lights on the shingles with the entire edge of the razor blade, exposing the bare board somewhat—I can dim these marks later with a wash. Next, with a No. 1 brush I do the vertical separations of the shingles, applying a full-strength mixture of the gray and the brown. I also reinforce the horizontal lines wherever the razor blade lightened them too much. Dipping into the green with a No. 5 brush, I drybrush the blotches on the barn, the adjoining structure, and the house. I then continue deepening and defining shape and texture on the walls, the road, and the grass. When I carry everything to the depth of value I want, I use a frisket knife to stratch in the light blades of grass, and an ink eraser to pick up the wheel marks on the road. Moving over to the roofs, I lighten portions with a kneaded eraser; this gives them a more interesting gradation. Now that I've recorded the mechanics of the painting, I'd like you to study the interplay of hard and soft edges: the combination of straight and playful lines is, to me, most appealing. Just one more thing: notice that I didn't use even a drop of white pigment in this painting. You can use white if you have to, of course, for minor corrections or for a tiny light detail over a dark passage—but it's a challenge to try not to.

Color Demonstration 6. Wooden Wharf and Harbor

Step 1. I moisten the alizarin crimson, the raw umber, and the ultramarine blue in the Pelikan color box after tracing the drawing onto a 15" x 20" piece of No. 80 illustration board and inking in (with Higgins ink and a No. 303 Gillott pen) all the lines I don't want to lose under subsequent applications of paint. I begin applying thin mixtures of Rich Art white with touches of the three colors mentioned above to get vibrant and pulsating grays. The brushes I've used so far are Nos. 5, 7, 11, and 15 flat sables. I pat and drag the flats, and rub the side of the brushes to get the uneven tones the fog would create. Also, I outline the moored boat, wharf, barrels, and lobster traps very simply.

Step 2. I continue the thin applications of paint with the same colors and the same brushes, with the addition of yellow ochre, until the entire picture area is covered. This is only a broad suggestion of things to come. As you know by now, this is the stage that I try to reach as quickly as possible. It establishes the general tonal scheme as well as the muteness or intensity of the color I intend to apply. It's done so quickly, by setting everything down only in the broadest terms, that no time is lost. If it doesn't come off, I can without compunction throw the wretched thing away and start all over again—you too must acquire the knowledge and summon the courage to dispose of anything that doesn't come up to expectations.

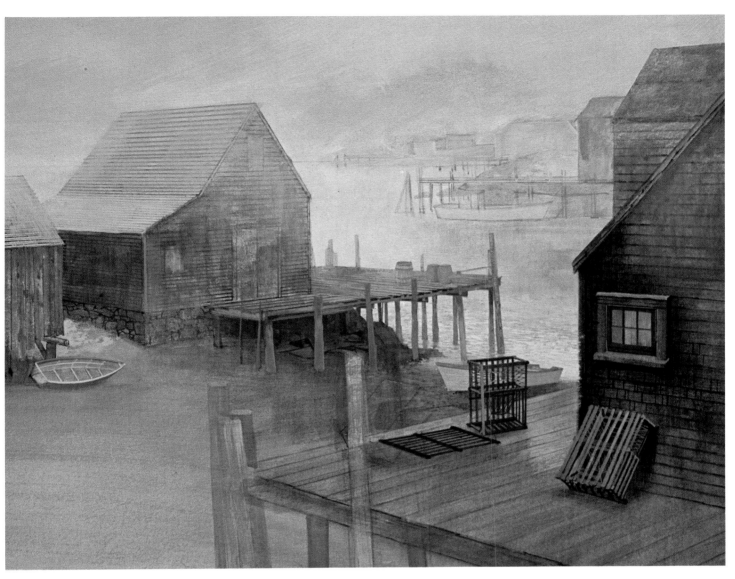

Step 3. I need specific information to fill in the shapes I outlined in Step 1, so I set out in search of them. I found a fishing boat at Sagamore, on the Cape, and did an accurate drawing of it on a clear, sunny day. I found the barrels inside a neighbor's barn and a friend lent me a lobster pot, all of which I render directly with brushes Nos. 1 and 2. Mark well the procedure I follow in doing the lobster pots—first, following the cubic forms established, I do the three back sides (check the one standing upright). Next, I do the nets inside, and finally I do the three sides facing the spectator, as on the one reclining against the wall. Having finished the lobster pots, I begin to pin down value and definition across the middle of the picture. I work my way above to the sky and below to the ground, keying the tones to the darkest (ultramarine and raw umber) notes next to the window on the right and under the dock in the center of the painting. Also, checking Demonstrations 17, 25, 27, and 28, I begin definition of the shack on the left and its rock foundation. I move over to the window on the right and do it, checking the pencil drawing I had done outdoors. The paint now is not so thin, and if the drawing threatens to get lost, I reinforce it with an office pencil.

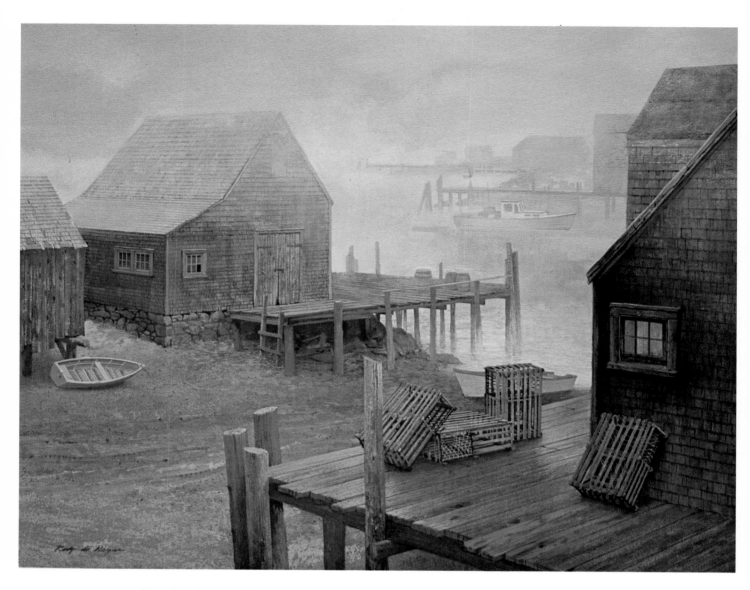

Step 4. Using a mahlstick and working with brushes Nos. 3 and 5, I drybrush the sky in thin mixtures of Rich Art white with touches of alizarin crimson, blue-green, and yellow ochre. Using the same colors I move to the far distance, then the middle distance, and down to the water. I soften edges and strive to keep the high key of the previous step as I define the elements just enough to make them read without destroying the foggy effect. Next, I finish the barns on the left, sub-duing the shingles on the roof by dragging the side of a No. 3 brush. Then, switch-ing from blue-green to cobalt blue, I do the ground, tapping a finely grained sponge and working slightly into the foreground dock. I finish the remaining pots—from the inside out—using the ruling method on the slats but not making them rigorously straight in order to preserve their battered state. Next I define the planks on the dock in quick strokes. I follow up with the pylons, working with the point and side of the No. 3 brush. Moving over to the window on the right, I add details with a No. 1 brush and define the shingles around it. The composition is based on thrusts to the right—the dock in the center and two of the boats—and on thrusts to the left—the docks in the distance, one boat, and the foreground dock.

Color Demonstration 7. Bridge Over a Marsh Before a Storm

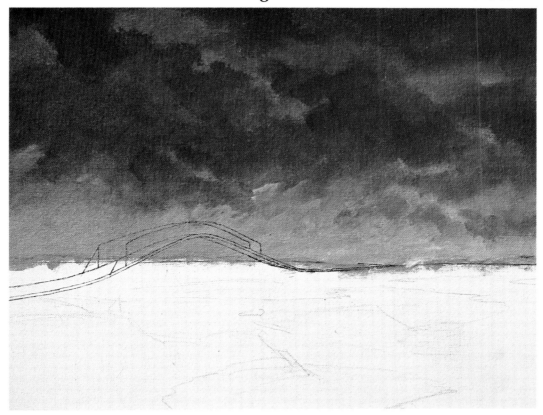

Step 1. I'm using a 16" x 20" canvas board—cotton canvas glued to cardboard—this time with liquid acrylic. Acrylic can be used on any surface.

After transferring the drawing to the canvas board, I ink in the main lines of the bridge with a No. 303 Gillott pen and Artone extra-dense black ink, so that when I indicate the sky, the lines won't get lost, even though I'm going to use very thin paint. I put large dabs of naphthol crimson, yellow ochre, and ultramarine blue in three cups so I can squeeze a sponge over them if they begin to dry. Consulting the preparatory sketch and Demonstration 15, I do the sky with a Simmons No. 6 bristle flat, dipping into all three colors, and working them slightly into the distant dunes.

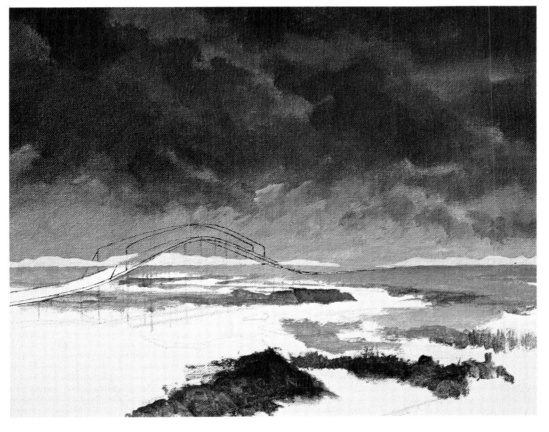

Step 2. Notice that the stormy sky takes more than half the space so that its turbulence and oppressiveness weigh down on the land. I continue on the ground, using as many diagonals as I can to convey the excitement of the scene. With a No. 7 flat sable and titanium white, I regain the contour of the dunes against the sky. I do the grass on the dunes, tapping and scrubbing vertically with the No. 6 bristle flat, using mostly the blue and the yellow with only a whisper of the crimson. I place the darkest dark (crimson and blue with a touch of yellow) on the ground so I can better judge the middle and the light values of the marsh.

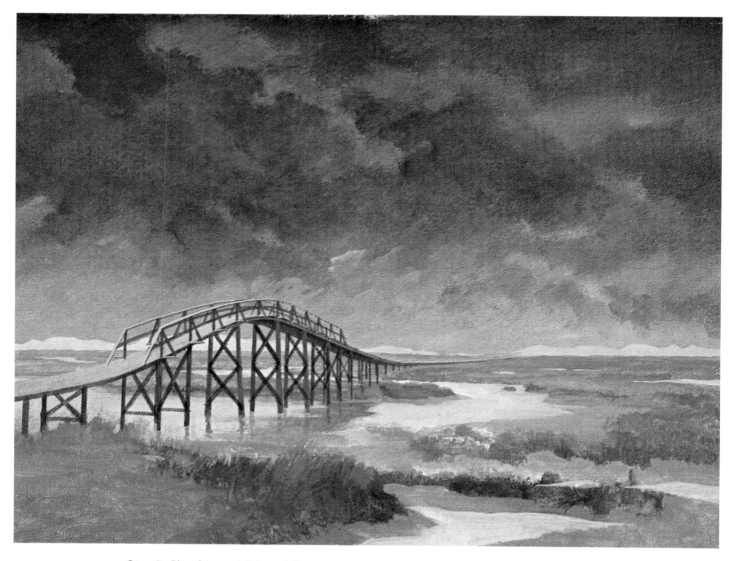

Step 3. Checking additional drawings made on the spot and following the inked lines of the bridge, I tackle its intricate construction, knowing now that its X's will pull the eye to it no matter what I do in the rest of the picture. I want the bridge to play a part second only to the sky because it's such a familiar landmark at Sandwich, on the Cape. I actually saw this dramatic scene, and it haunted me through the intervening weeks while I was engaged in other work. A few days later another storm came our way and gave me the chance to do Demonstration 15. I have of course made the necessary modifications to suit this particular purpose. Any picture not precipitated by emotion isn't worth its pigment—Cézanne once said words to that effect. My point is that you too must be haunted by a scene and feel intensely what you paint, or the game will not be worth the candle. I continue using only the three colors and white with a No. 7 flat sable for the large areas and brushes Nos. 1 and 3 for the smaller ones. It is at this stage that I relax. The underpainting is done and I've nothing left but the fun of determining the color, accentuating textures, and defining details.

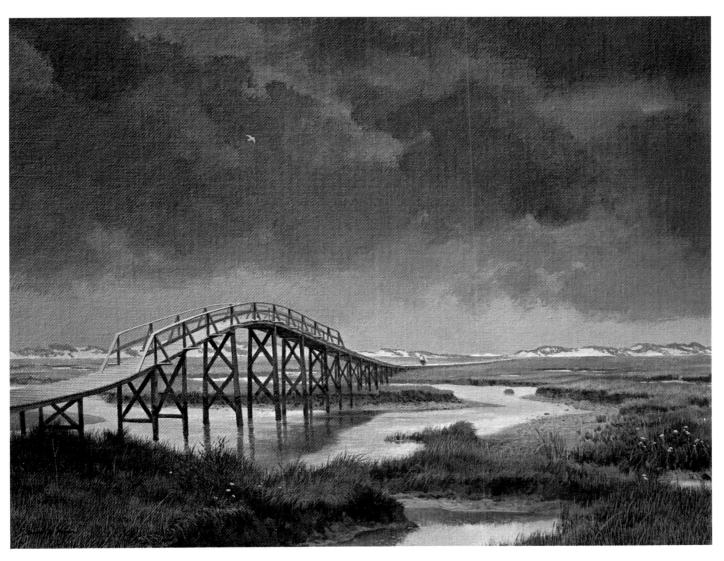

Step 4. I begin to finish the far distance with flat sables Nos. 8 and 10, doing the dunes and the adjacent sky so I can work one into the other while the pigment is still wet. As I work the sky at the horizon with all three colors and white, part of the bridge gets lost. So, checking the pencil drawing, I restore the bridge in ink with the Gillott pen No. 303. Then I move down to the inlets, using thick paint; the trusses of the bridge almost get lost, but I can still see them. Next I do the rest of the marsh, adjusting shapes and textures to pull the picture together as a unit. Originally I intended the lower left corner to be bare ground (as it actually is), but the marsh was getting too spotty and began to detract from the stormy sky. So, with a No. 1 brush I extend the grass all the way to the edge. I use a Liquitex yellow-green—Value 7—to do the moss on the stanchions because the mixture of blue and yellow I've been using isn't vivid enough. Then I do the tiny figures on the boardwalk with a bit of cadmium yellow light and a No. 00 brush. Just one more thing. I know that as a rule the gulls lie low and seek shelter during a storm, but fie and forsooth! I need a white speck up there defying the elements.

Color Demonstration 8. Rocks and the Sea

Step 1. I'm going to use Homosote as a support this time. I coat its canvaslike surface with Liquitex gesso and when the coat dries, I transfer the drawing to the board. Then, with Grumbacher Pre-Tested oil colors alizarin crimson, yellow ochre, and permanent blue (ultramarine blue), I set down light and dark notes throughout the picture with a No. 6 bristle brush, using MG quick-drying titanium white for the light ones. I trace only the contours of the rockbound shore and some of the big shapes on the water, but no details.

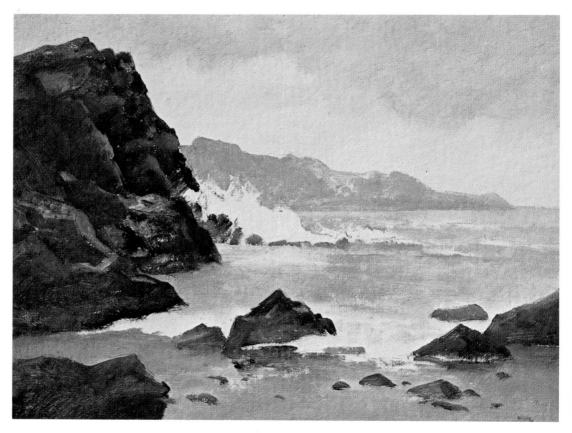

Step 2. Note how I've used the diagonals throughout the painting to convey the excitement and animation of the sea. The pure whites you see are the gesso itself, and I've silhouetted their shapes with the No. 6 bristle flat. For the large shapes I use the entire brush, and for the smaller ones, like the rocks on the beach, I use its corners. When the underpainting is done, I place it against the wall to dry overnight. Then I go to the beach to study once again the behavior of the surf as it ebbs and flows. Upon my return to the studio, I make visual and written notes of my observations.

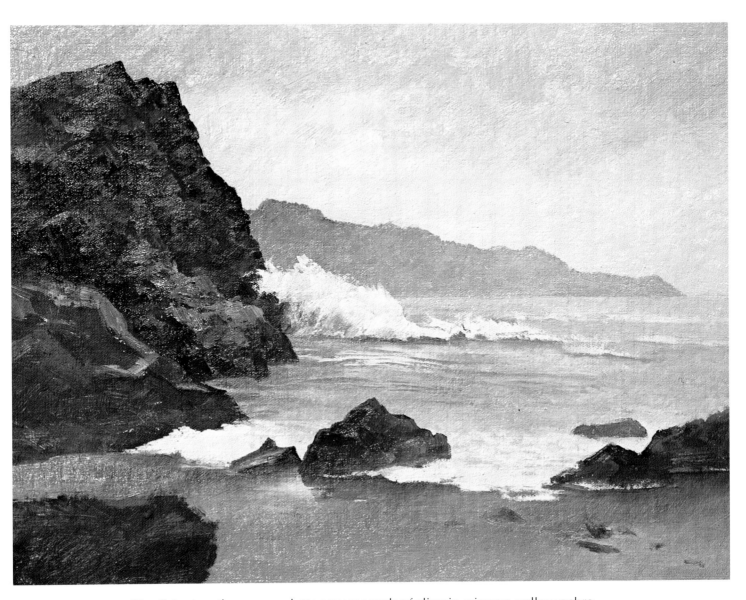

Step 3. I set on the paper palette new mounds of alizarin crimson, yellow ochre, and ultramarine blue, and Superba white rather than titanium white. With a flat sable No. 12, and brushes Nos. 1 and 3, I work on the crashing wave, using thick white with whispers of blue and yellow to model the form, letting one or the other dominate for the cool and warm tints. I move then to the rest of the water, and mixing color as I work my way down to the beach, I strive to get the restless, heaving motion, without giving undue prominence to the strokes. I can so easily succumb to the sensuousness of oil paint that I find myself making a deliberate effort not to revel in the handling of it, as the brush glides, wiggles, and dashes across the surface.

As I begin to paint the beach, I notice that the rock at lower left is beginning to bother me. Even though it works well in the preparatory sketch, it exerts too much tension in that corner at these larger dimensions. I move over to the cliff, and with flat bristles and pointed sables I continue to develop its textures and configurations. Then, with the same mixtures and smaller brushes, I begin the definition of the rocks.

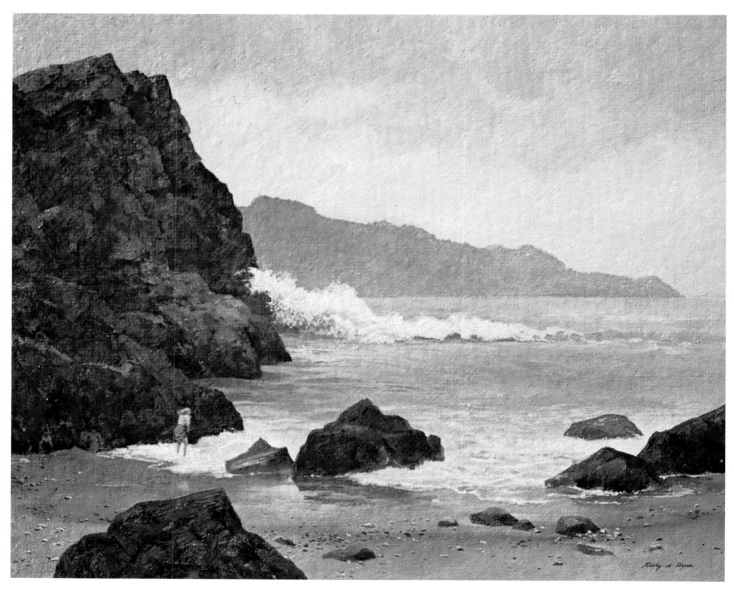

Step 4. My concept here is a misty, cloudy, summer day, when the wind blows fresh and cool from the sea, and you have an overpowering desire to remove your shoes and walk the wet beach. One of the observations I jotted down after studying such a day at Sandwich was that as the surf recedes, it leaves beautiful light and lacy patterns on the dark, water-soaked sand. Another was that reflections on the wet beach are clear enough to play up in color and in shape. Notice how the rock in the center is clearly mirrored. I paint now in the confines of the studio, but I feel the excitement of the scene as I experienced it.

While working on the rocks and pebbles on the beach with Nos. 1 and 3 brushes, I decide finally to reshape the rock in the corner because its top edge leads the eye out of—instead of into—the picture. Then I add the figure to give the scene its proper scale, but as I do this (everything being relative), the crashing wave becomes gigantic. So, I trim the crest with the color of the distant shore. Finally, after adding more pebbles to the beach, I move over to the water and kill the lines below the wave because they look like ripples, which, of course, would be out of place on a heaving sea.

WATER, SNOW AND ICE

One of the advantages of working from life is that you can't help being imbued with the spirit of the subject. Being aware of the smell and the sound of a place in addition to its looks will heighten the impact of the visual statement. This is what happened in the following group of demonstrations.

DEMONSTRATION 20.

Still Water

I doubt that there's anyone interested in landscape painting whose eye hasn't been caught by the shimmering reflections on still water. It so happens that there's a pond on the grounds of my Cape Cod studio, and there was no question in my mind that someday I'd paint it. It became a ritual for me to bring my luncheon to its banks and just sit there munching away while studying its characteristics. It seems to me that the more you're saturated with a certain subject, the better chance you have of painting it successfully. After many luncheons, the afternoon finally came when I brought my sketching materials to the spot and painted this view. I used the Paper King pad, the Pelikan box, white opaque, a sponge, the No. 12 flat sable brush, and watercolor brushes Nos. 1, 2, and 3.

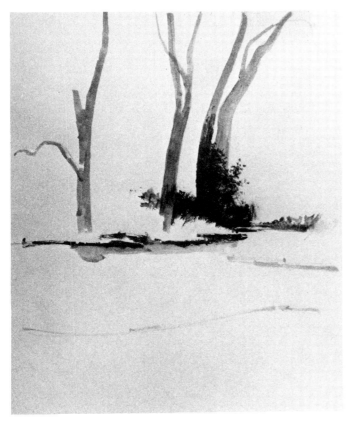

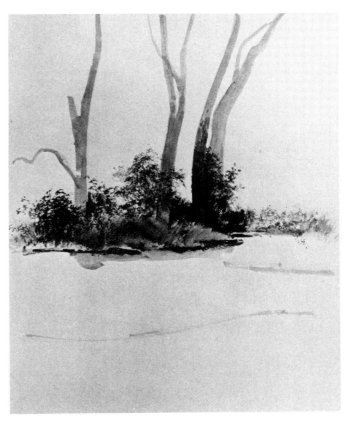

Step 1. I dip a No. 3 brush in diluted mixtures of raw umber and black from the Pelikan box to sketch in the trees. There are actually more trees in this scene than the ones I indicate—I exclude some to strengthen the design of the picture. Next I broadly indicate the shape of the pond. I was tempted to use a sponge to render the bushes at the base of the trees but decided instead to do them with a No. 2 brush. Dipping almost entirely into the black to establish the darkest note on the opposite bank, I let these bushes become a tonal reference for all the other values in the sketch.

Step 2. Seeing now that it would take too long to do all the bushes with the brush, I switch to a sponge. Tapping mostly with its corner, I finish the bushes using the same mixture of raw umber and black that I used in Step 1. Then I empty the sponge on a piece of scrap paper, and with the little amount of ink left in the sponge I brush upwards to suggest the grass on the opposite bank.

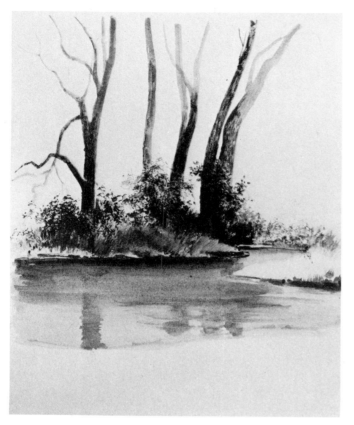

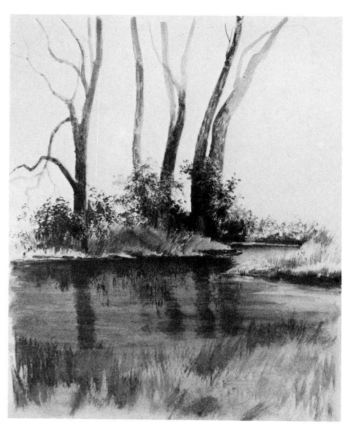

Step 3. The original light tones on the trees from Step 1 serve only for placement—when sketching in watercolor, I usually indicate the placement of things lightly at first, and then I deepen them to their proper values. I do this here, as I deepen the tone of the trees and suggest some of the bark with the No. 2 brush and a slightly thicker mixture of raw umber and black than I used before. Switching to a No. 3 brush, I apply the first wash made of that same mixture on the pond (again only for placement of shapes and not in their true, deep tone) and hint at the reflection of the trees on the water.

Step 4. Now I darken the reflections of first the bushes and then the trees on the water with a No. 2 brush. I also deepen the tone of the lower part of the pond, adding the grass with an umber wash and the corner of the sponge.

Step 5. (Right) I switch to a No. 12 flat sable brush and deepen the water still more in horizontal strokes. I also darken the reflections of the trees again. Next, dipping a No. 1 brush first into white opaque and then (immediately) into the black and umber puddle, I mix the light tint needed to define the ripples on the water. Finally, with the side and heel of the No. 3 brush, I render both the dark and the light details of the grass in the foreground.

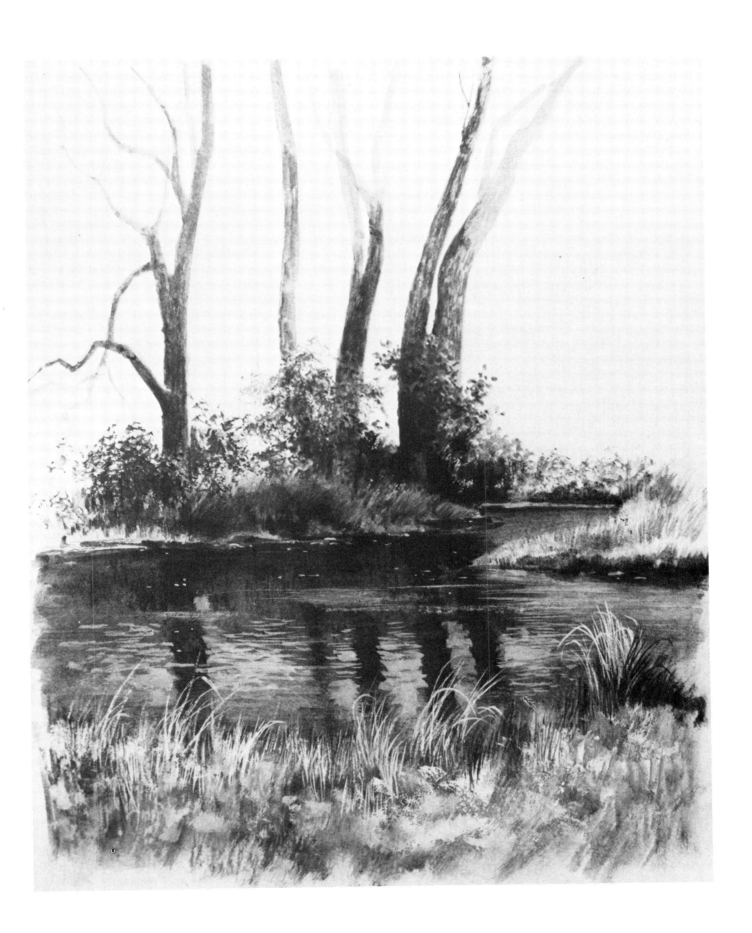

DEMONSTRATION 21.

Frozen Stream

I always felt that this sketch, or part of it, would eventually become a painting for many reasons, not least among them the fact that the subject is a few yards away from my studio. I could easily sketch it from my car in my own driveway. As you know, every time I do a sketch, I do it with an eye to its becoming a painting later. Not all my sketches reach this final goal, but that's my intention anyway.

To me there are always ". . . books in the running brooks . . .," and I can just stand there listening to their babble without lifting a brush. But on this nippy day I set immediately to work, concentrating entirely on what this frozen stream had to tell me visually. The ice had just begun to form along the banks of the brook, and the combination of sheen and texture begged to be painted—and who can ignore a plea like that!

The materials I used are: No. 80 Bainbridge illustration board, the Pelikan box, white opaque, a razor blade and sponge, a No. 12 flat sable brush, and watercolor brushes Nos. 2, 3, 5, and 6.

Step 1. I begin by doing the upper band—the background—with equal amounts of umber and black, and a No. 12 flat sable brush, obtaining the gradation of tone by adding water as I work my way to the right. I follow the same procedure on the stream. Then, still using the No. 12 sable, I indicate the ice beginning to form on both banks with a very diluted mixture of the umber and black. I forgot that I was using such a diluted—thin—color, and as I slanted the board a bit too steeply, the run, i.e., drip, on the left was bound to happen. If I were working on an aquarelle, this would be a problem. Since I plan to use opaque color later, however, I'll easily correct this mistake.

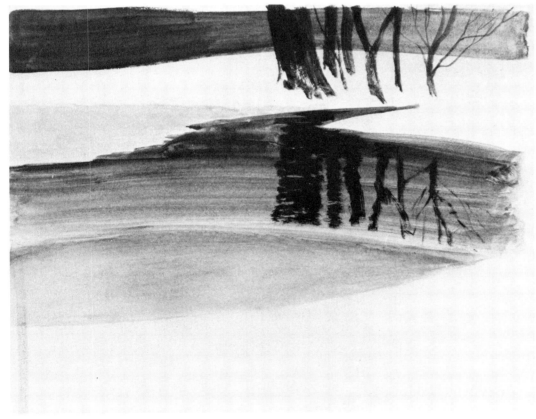

Step 2. So far, I'm pleased with the simplicity of the large shapes. Now it's time to introduce smaller ones to complement them. With a No. 3 brush I indicate the trees against the snow and their reflections on the water. Again, as in the sketch in Demonstration 20, there are more trees than I show—I can't help rearranging nature.

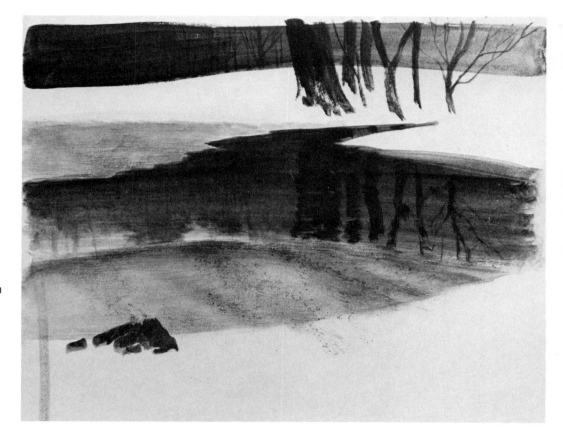

Step 3. Now with a No. 6 brush I deepen and smooth out the water. Then I work on the ice with a fine-textured synthetic sponge. Next, I define the ice still further with the No. 6 brush. Switching to a No. 5 brush, I indicate the trees on the background band and the foreground rock with a very dark tone of umber and black.

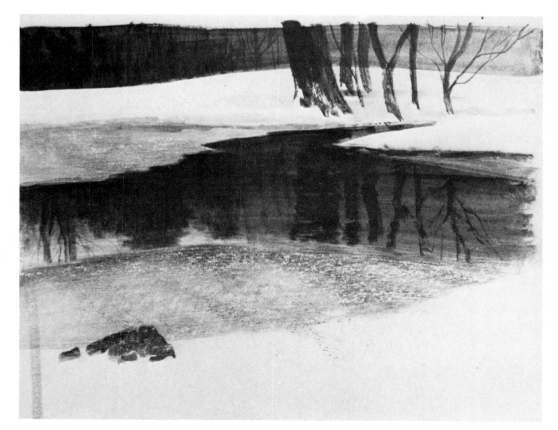

Step 4. I scrape the ice with the entire edge of a razor blade, mainly to give it a more realistic texture but also to make the tone lighter. Then I define all the reflections on the water with a No. 3 brush and a dark tone of umber and black. Next I wet the area at the base of the large trees and float a tint there to suggest the snow bank.

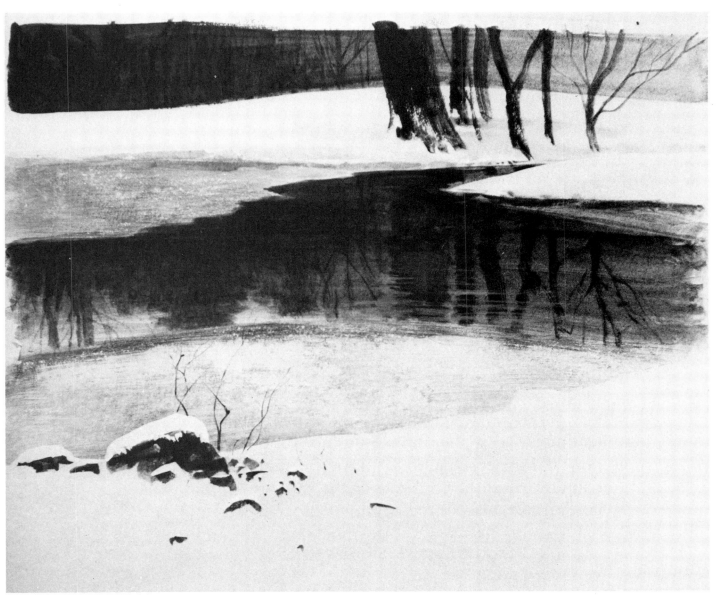

Step 5. Here I add the pizzicati of the smaller rocks with a No. 2 brush to add interest to the simple foreground. Then I clean up the top of the bank at upper right and the edge of the snow against the ice in the foreground with white opaque. Now, while I have the white on the brush, I kill the run at lower left. Finally, still using white, I stroke vertically and horizontally, and I drybrush the foreground to lighten the ice there.

DEMONSTRATION 22.

Puddles

There's something so entrancing about puddles and the reflections cast upon them that few of us can resist including them in sketches—they're so decorative that many a painting's charm would suffer were they to be left out. There's a park nearby where my dog, Olivia, loves to take me for a walk. I've seen and studied every corner of it during our saunterings, but one particular time—after a downpour—we came upon these puddles. I stood there, fascinated, and decided that I really *had* to paint the puddles. So I brought the car with my materials in its trunk over to the spot and began to sketch on Fabriano watercolor paper, using the Pelikan box and white opaque, and watercolor brushes Nos. 1, 2, 3, and 6, and the No. 12 flat sable.

Step 1. I rub a No. 2 brush dipped in water on the black cake of the Pelikan box, and with a very light tint I sketch the shape of the puddles right away. Then I make a thin mixture of black and raw umber, and I emphasize the contour of the puddles with a No. 6 brush. I'm working with a pointed brush for greater control in articulating the edge of the ground around the puddles.

Step 2. Now with the same raw umber and black mixture, I cover the rest of the ground, using a No. 12 flat sable brush. I brush in quick strokes to bring out the surface of the Fabriano paper so that it simulates the texture of the ground.

Step 3. The trees on the horizon are indispensable to the design of this sketch because of the part they play in giving interest to the puddles. I take the time to do them as faithfully as possible with a No. 2 brush, raw umber, and black. Keeping in mind that the light comes from upper left, I stress the shadows on the right side of the trees to give them form.

Step 4. I float clear water from my water jar within the puddle shapes with a No. 3 brush. While those areas are still wet, I paint the reflections of the trees in the puddles to get the soft edges that I want. Then with a No. 6 brush I darken the ground around the puddles to brighten them up by tonal contrast.

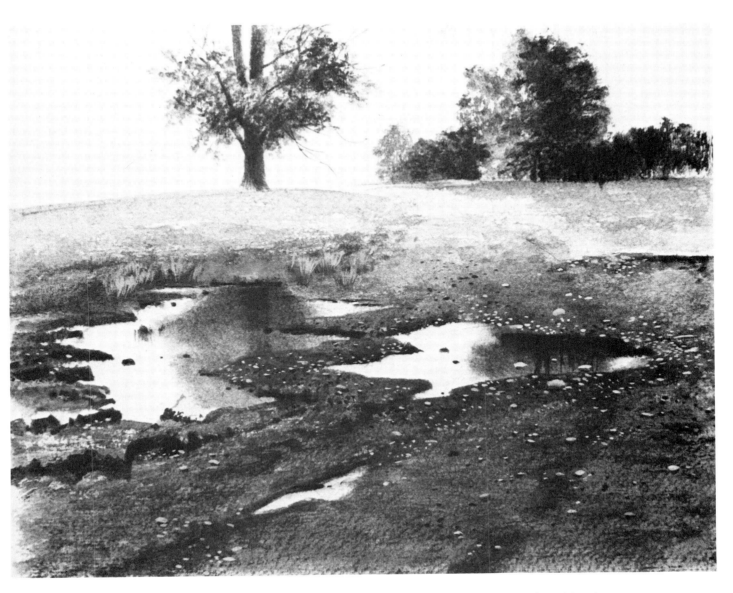

Step 5. So far, I've done this sketch in the classic watercolor manner: the whites in the picture are the whites of the paper itself. But now I load the No. 1 brush with white pigment, work it into the puddle of umber and black to get a light gray so that I can render the pebbles all over the foreground. Next, dipping into the same light gray, I do the tufts of grass above the puddle on the left. Then I emphasize the form of the trees by deepening their shadows. And finally I articulate the light and dark pebbles within the puddles.

DEMONSTRATION 23.

Surf

With the sea breeze in my nostrils and the cries of the gulls in my ears, I couldn't help doing a good job on this sketch. I think it's good enough to develop into a painting some day. There are subjects that because of their agitated and restless aspects seem to be beyond our capacity to pin down. But if you'll study the surf next time you have a chance, notice that during the time required to sketch it (less than one hour) fleeting incidents continue to repeat themselves, making it easy to set them down. To do this sketch as quickly as possible, I chose to work on a gray chipboard so that all the middle values would already be there, and I'd have to contend only with the lights and darks. I used the Gamma grays, white and black opaques, watercolor brushes Nos. 3, 5, and 6, and the No. 12 flat sable brush.

Step 1. I like to work from the background forward, so I began here with the sky. I dip into the No. 2 Gamma gray with a No. 12 flat sable brush; then without rinsing the brush I dip into the No. 4 gray as I work my way from left to right. Next, with the No. 3 gray with a No. 5 brush, I do the strip of land and the water under it, leaving the gray of the board itself between the land and water as a separation. After rinsing the brush, I mix some No. 5 gray into the No. 3 and indicate the bay on the left. Notice that there's no preliminary pencil drawing in this case as it would get in the way of an active and exuberant subject.

Step 2. Here I paint in what I could hardly wait to do—the surf pounding on the rocks. This is the reason for the sketch—anything else plays only a supporting role. I transfer some white from the Rich Art jar to the tray, dilute it a bit with water on the No. 5 brush, and stipple the edges (hold the brush perpendicular to the chipboard and tap vigorously) to get their feathery character.

Step 3. The No. 5 gray and black come into play now as I do the rocks. Beginning at the left with straight No. 5 gray, I use a No. 3 brush and gradually add black as I move to the right. Both the light lines and configurations between the tones are again the light gray of the chipboard itself.

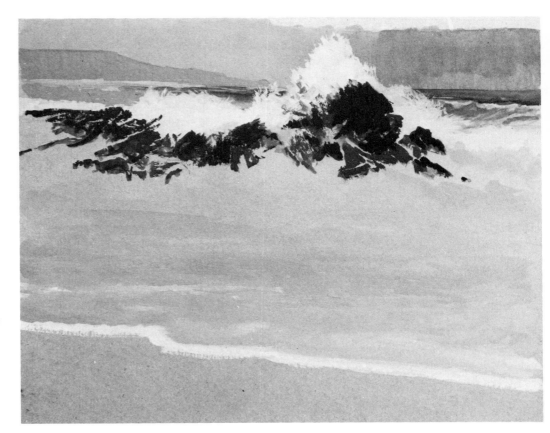

Step 4. As I move forward to the front plane of the picture, I dip into the No. 3 gray with the No. 6 brush and apply very thin washes just slightly darker than the board itself. These washes serve as a base for the white spume coming up next. Than I indicate the white edge of the foam as the water flows over the sand.

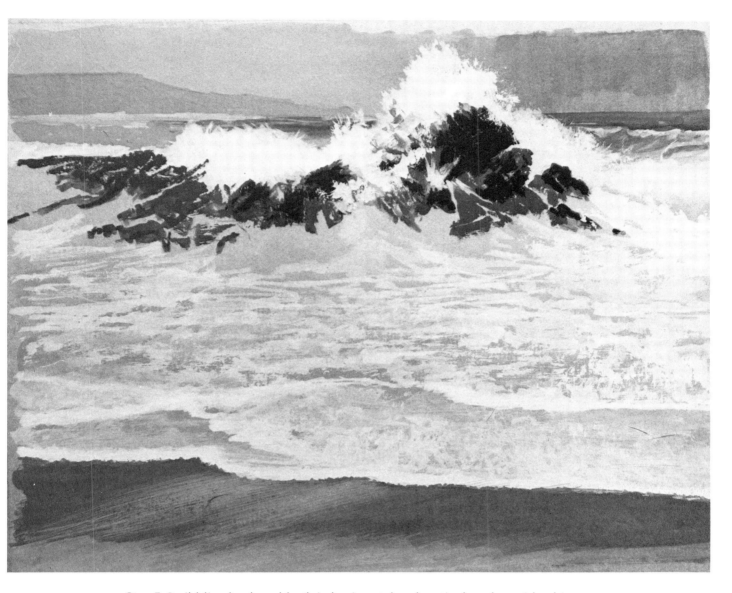

Step 5. Scribbling back and forth in horizontal and vertical strokes with white using the No. 3 brush, I do the spume on the spent wave reaching the beach. I'm using the tip, side, and heel of the brush to get the character and the motion of the foam with as much spontaneity as possible. Then, with No. 4 gray, I trim the white edge in the foreground. Next I drybrush a No. 3 gray over the foam at left to show the water rushing back under the oncoming spume.

DEMONSTRATION 24.

Snowbanks

To depict the great variety, the bounty of nature, from the abundance of summer to the starkness of winter, I couldn't possibly omit a snow scene. I didn't have to wait long for "the fairest meadow to be white with snow." I found the scene I wanted to sketch at the same pond where I did the picture in Demonstration 20. I set to work with 4H and 5H pencils on an 8" x 10" Flax media-coated pad, a clay-coated paper that gives dark tones even with a pencil as hard as a 5H without using any more pressure than usual. If your local shop doesn't carry the pad, then ask them to order it from Sam Flax, in New York City or Atlanta, Georgia. Its greatest advantage is that you can continue to draw without having to stop and re-sharpen your pencil all the time, though I had a sand-paper block and matknife for sharpening just in case. As you can see, even though I used nothing but a pencil, I still got valuable information for a future painting. To help me at that future time, I wrote down color notations on the margin of the sketch.

Step 1. I use the 4H to describe the outline of the trees and the horizon lines. (When you do this, be sure to place a piece of paper under your hand to avoid smudging.) Then, starting with the biggest of the trees, I do its trunk and the snow clinging to it in vertical strokes following the form, using only very light pressure.

Step 2. I continue adding tone to the other trees, pressing lightly on the 4H pencil to get the grays I want. If I get too dark a tone anywhere, I can lighten the area by tapping a piece of kneaded rubber over it. I hope I don't have to do this since the process would mar the freshness and directness that a pencil drawing should have.

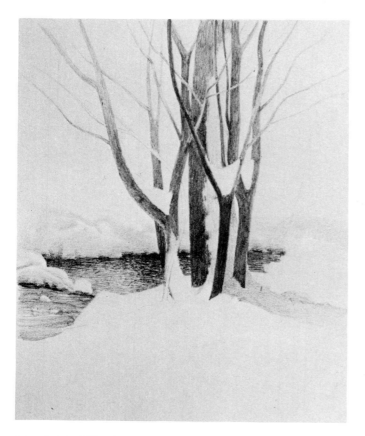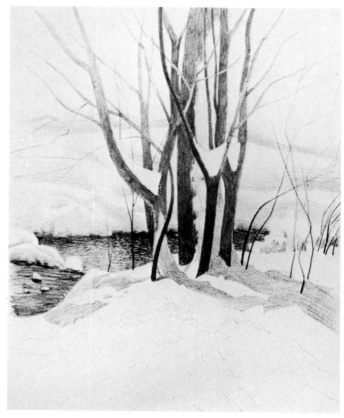

Step 3. It's difficult to stop working on the trees, but I must go on to the stream and the snowbanks, which are the reason for this drawing. I do the stream first with the 4H pencil and then switch to a still harder pencil, a 5H, and begin the snow on the opposite bank. I hold the pencil under the palm and make sweeping strokes lightly, with my hand off the paper.

Step 4. Now I sharpen both pencils with a matknife and bring them to a sharp point with a sandpaper block—in this type of drawing I use only the point and not the side of the lead. Then I outline the shapes of the shadows in the foreground to fix their position and begin to shade some of them in. I also add more tone to the snow in the background.

Step 5. (Right) I'm still holding the pencil under the palm and drawing in light, sweeping strokes with my hand off the paper as I work on the shadows. When I draw the twigs and the thin skeletons of bushes and weeds though, I rest my hand on a piece of paper. Then I return to the trees and define the bark with the 4H. Do try this type of paper—it can give you extremely delicate and beautiful effects.

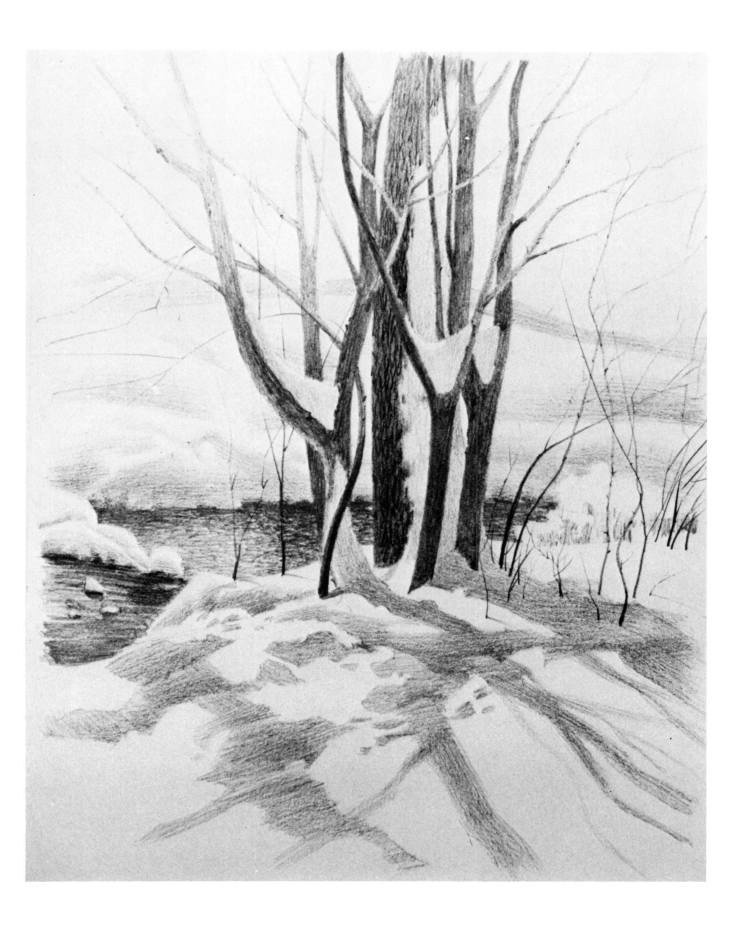

MANMADE OBJECTS

I'm always elated when I find something exciting to paint—but in the midst of joy, a sadness descends upon me when I realize that there are in the whole of New England many beautiful things I shall never see. Some of these beautiful things were made by man, such as the objects in the following five sketches.

DEMONSTRATION 25.

Stone Wall

I remember remarking in one of my books that art isn't so sacred that we should be intimidated or awed by it—or words to that effect. But neither do I want you to get the idea that it's a frivolous and irresponsible pursuit. Nothing that we dedicate our lives to can be. To be specific, landscape painting is a serious endeavor and should be approached not with trepidation but with love and respect.

This is how I approached the stone wall in this demonstration. The materials used here are the Paper King pad, an HB pencil, the Pelikan box and white opaque, and brushes Nos. 1, 2, and 3.

Step 1. The pencil drawing in the preceding demonstration was only a rough scratch—this one must be carefully done because I'm going to use the raw umber and the black as transparent watercolor. I sketch this with an HB pencil. I set down the black tone first so it can be my guide to the lighter values which I begin painting at the top of the wall. I'm using the tip and scrubbing with the side of the No. 2 brush with tints first of umber, then of black, and finally of both. As I do this I notice that the drawing is getting lost—I decide to secure the contour of the rocks before continuing.

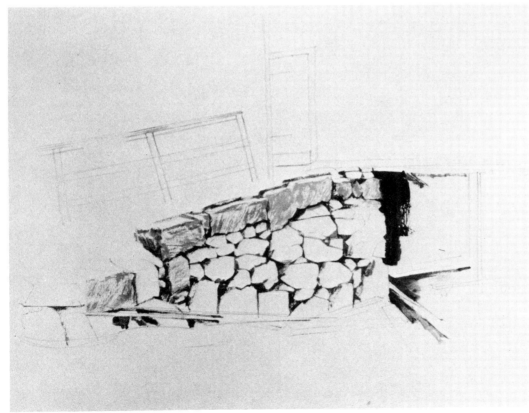

Step 2. To pin down the shapes of the rocks, I dip the No. 2 brush into black and raw umber and paint the contours. Now I can scrub their texture without fear of losing the drawing. Using the same brush and the same colors I begin indicating the boards on the ground.

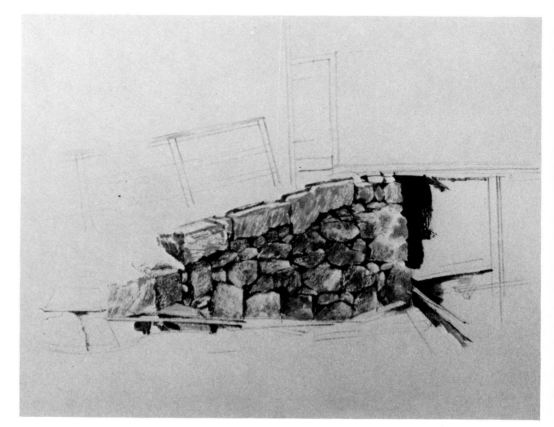

Step 3. As it was a bitter cold day, even in the car, I was tempted to stop here—when conditions are unfavorable, I sometimes go straight for the motif I want, disregarding any other element that may enhance the sketch. But I thought a few more strokes wouldn't take too long, so I continued scrubbing the textures of the rocks, still using the No. 2 brush.

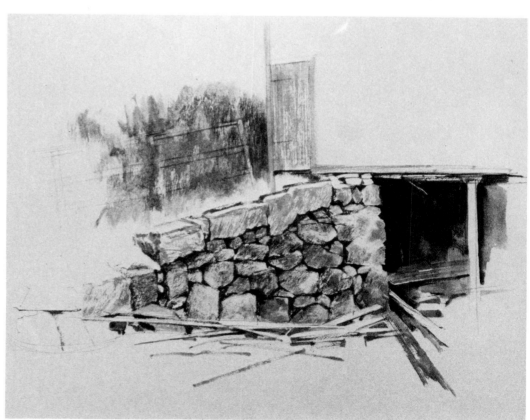

Step 4. In this step I strengthen the pencil lines on the fence so they won't get lost when I rub a tint—mostly of umber—over them. I rub in the tint and then I drybrush the door, continue with the rest of the boards on the ground, and finish the dark shapes under the barn with a No. 3 brush.

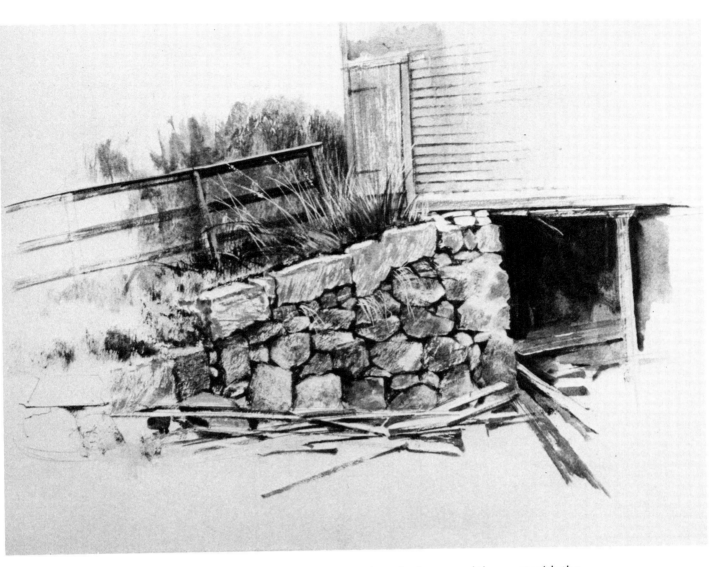

Step 5. Using brushes Nos. 1 and 2, I articulate the fence and the grass with the black and umber. Then I pick up white, mix it with the colors on the tray, and do the top board of the fence, as well as the light blades and stalks of grass leaning against it. I float a wash around the door next and suggest the shingles. Finally I dip again into the white and do the few leaves of grass creeping between the rocks of the wall.

DEMONSTRATION 26.

Wooden Fence

As a rose is a rose, a fence is a fence—and we all know its function. Perhaps that's the reason we neglect it and give it nothing but a supporting role in a painting. However, *anything* in this world can play a starring role if you give it a chance. If "good fences make good neighbors," then a good fence can make a good painting.

I used India ink, raw umber and white opaques, a sheet of Fabriano paper, the office pencil, a sponge, a ruler, and brushes Nos. 1, 2, and 3.

Step 1. I draw only a very rough pencil indication of my subject with an office pencil because I can straighten out and refine details later. I dip into the Artone extra-dense ink bottle with a No. 2 brush. Using the ruling method, I do the straight lines on the gate. Then, taking advantage of the surface of the paper, I rub the side of the brush on the granite pillar at the corner to get its texture.

Step 2. With the supports of the gate boldly established, I can now tackle the background tree without fear of losing them. With the edge and corner of a synthetic sponge dipped into a puddle of slightly diluted ink, I tap the shape of the tree right over the upright and diagonal beams of the gate—I can clean the beams later with opaque pigment. Before rinsing out the sponge, I also do the foliage on the left.

Step 3. With brushes Nos. 2 and 3 and diluted ink, I do the gate, fanning the No. 3 brush so I can get the texture of the wood. I continue with the post and the adjoining fence (which happens to be the same one that begins at the corner of the barn in the preceding sketch).

Step 4. Now with a No. 1 brush and ink straight from the bottle, I secure the front rail fence. When this is done, I press the edge of the synthetic sponge into the puddle of ink on the tray again, and in varying degrees of dilution I rub it in upward strokes in the foreground for the foundation of weeds and grass I'll define next.

Step 5. (Right) At this final stage I dip into the Rich Art white with brushes Nos. 1 and 2, and working the white into the ink puddle to create gray at whatever degree I need, I render the last details. Beginning with the grass and the weeds, I start with the ones in the back and work forward. I must mention that I add raw umber to the gray mixtures so they match the warmth of the India ink. Next I articulate the rails, and when they are done I overlap a few weeds and grasses over them.

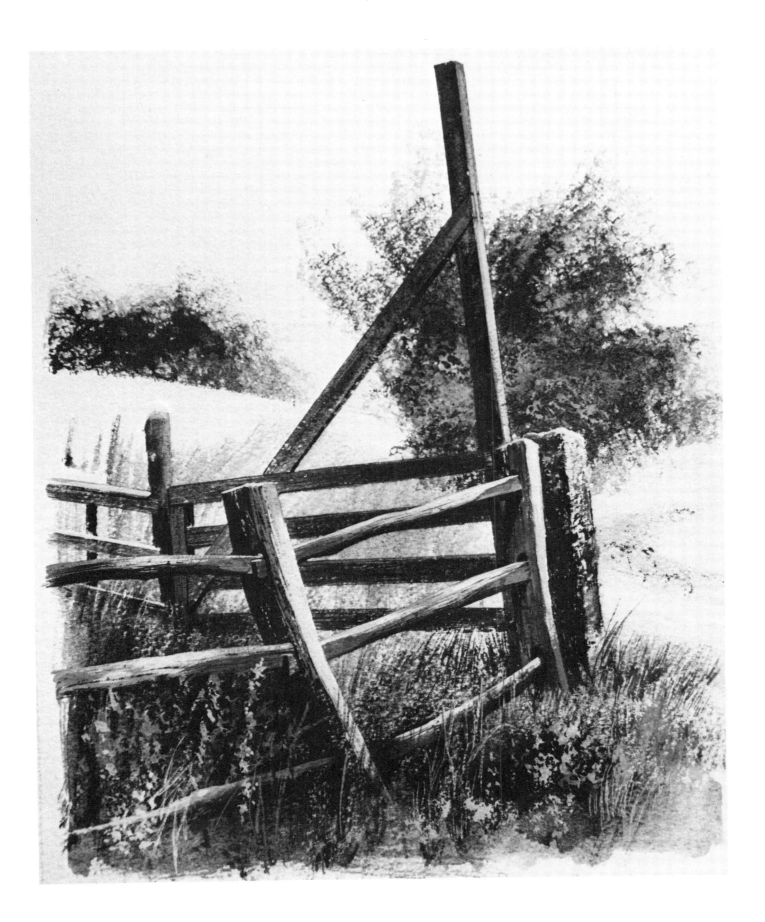

DEMONSTRATION 27.

Old Wooden Barn

Somewhere in the outskirts of Amherst, Massachusetts, is the terrific group of buildings I sketched here—they're arresting in shape and texture and touching in their decay. I have a feeling that this is only the first of many sketches that this subject will yield—remember that when you find a lode, you should keep on digging. Just as Corot used to walk around a tree until he found the best angle, so I walked around the place looking for the best view. All angles were thrilling and impressive, so I returned to the car and did the sketch from the spot where I'd originally parked.

To expedite the prevalent texture and color of the farm, I chose a piece of No. 80 illustration board, and the raw umber and black from the Pelikan color box. You've noticed, I'm sure, that I dip quite often into the raw umber and black—when these particular colors are depleted, I order new individual cakes from Grumbacher in New York to replace them. The other materials I used were a 3H pencil—the harder the pencil, the less chance for the graphite to smudge when I float a wash over the sketch—the No. 20 flat sable, and watercolor brushes Nos. 1, 2, 3, and 6.

Step 1. I begin by sketching a very rough indication of the buildings on the illustration board. Then, since the prevailing color of the scene is a warm gray, I choose the raw umber and black from the Pelikan box. After wetting these colors, I transfer them to the butcher's tray and mix a warm tint with the No. 20 flat sable. With a fully loaded brush I stroke back and forth horizontally and float the wash from the top down, holding the matboard at an angle of 45°.

Step 2. Here I pin down the important structural accents with black and a touch of umber (for warmth of color). I'm using a No. 1 brush and a ruler for all the vertical lines—though I do the diagonals and horizontals freehand. At this time I debate whether I should include the cast shadows—they're at the wrong angle and it'll be hours before they change.

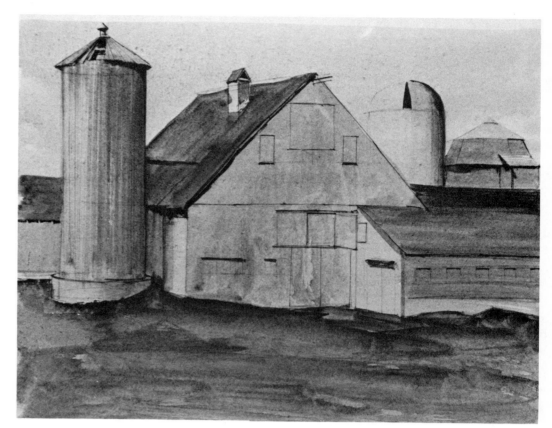

Step 3. I have to make up my mind about the cast shadows. As they're part and parcel of the tonal scheme, I decide to include them. With the No. 6 brush I give form to the silos by establishing their light and shadow areas. Then I apply the relative tonal values to the roofs, the sides of the buildings, and the ground. All this without any thought of detail or texture—that comes later.

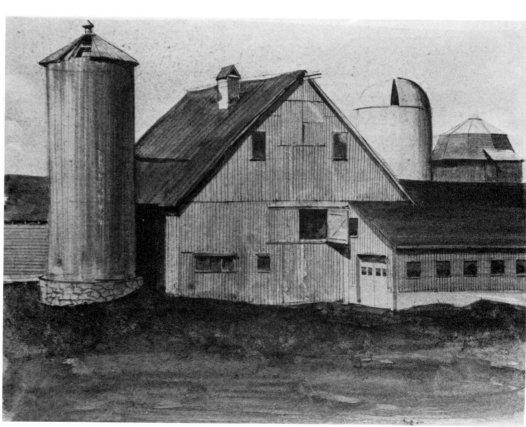

Step 4. I begin to articulate detail on the main barn by doing the boards with the points of the No. 2 brush, using the ruling method. I move over to the shed on the right and indicate its boards in the same manner. Then I suggest the metal roofing on the barn, accentuating the form of the silo at extreme right. Next I begin working on windows and doors. Now you see why I hesitated about the cast shadows—their contribution is negligible.

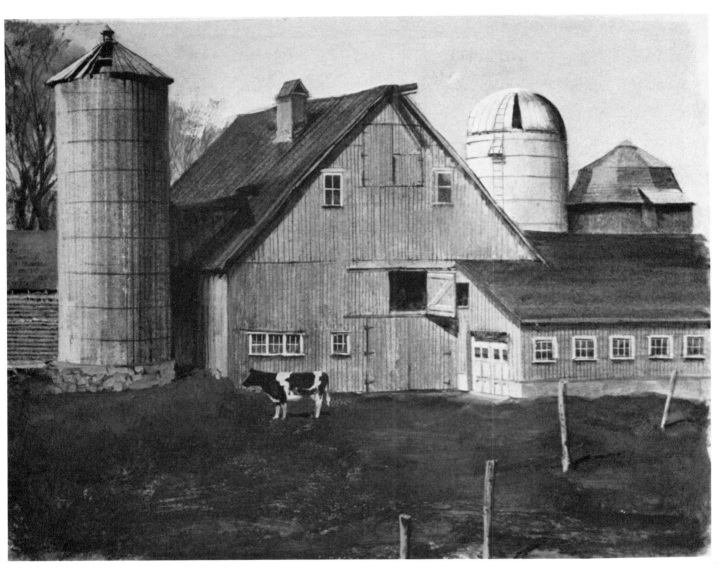

Step 5. Now adding white to the umber and black and using brushes Nos. 1, 2, and 3, I work my way from left to right. I do the trees, clean up the left side of the silo, add its details, and move on to the silos on the right. Then I finish the windows, deepen the yard, and add the posts. Finally, I paint in one of the many cows in the place, just for scale.

DEMONSTRATION 28.

Wooden Wharf

An old wharf is still one of my favorite subjects even though many artists shy away from them as being a bit too fetching and picturesque. But I paint what I love and the devil take the hindmost. I can't resist the lichenous stanchions and sagging platforms with their weather-beaten planks, holding the untold opulence of lobster traps and rusty old barrels besides the rest of the fishermen's gear. It's at lovely places like these, unfortunately, that the painter must steel himself to acknowledge whatever comments are made by the group of spectators that invariably gathers round, especially in the summer months. But carry on even if with only half an eye and half a brain, just as long as your whole heart's in it.

The materials this time are the Paper King pad, Gamma grays plus black, an office pencil, a sponge, a No. 12 flat sable, and watercolor brushes Nos. 1, 2, and 3.

Step 1. I draw the pencil lines for the rough sketch freehand, pressing lightly on an office pencil that I hold under the palm. My perspective is only approximate because even though I'm aware of the eye level, I'm not using vanishing points. I thin a No. 3 gray on the butcher's tray with the No. 12 flat sable brush and apply it, keeping it uneven in tone because I want to get the stained character of the shingles and the weathered boards from the beginning. I'm tempted to float a tint on the sky area but decide I don't need it.

Step 2. Remember that the best way to begin any pictorial statement is with the big shapes. Here I add the shape of the cove and the shadow under the shack on the left with a No. 4 gray. After rinsing the brush (still the No. 12 flat), I dip into the No. 1 gray and brush it on the roofs. The design of the picture is now established, and I think it would make a good painting.

Step 3. Still working with the No. 12 flat sable, I dip into the black and the No. 5 gray to deepen the shadow under the wharves. Then, with the No. 3 gray and a No. 3 brush, I extend some of the boards on the left and put in the stanchions on both the platform in the foreground and on the wharf. I'm just placing them now—I'll add form and texture later.

Step 4. Pressing the broad side of a synthetic sponge into the No. 2 gray on the butcher's tray, I tap it on the shore. Then I move over to the cove and indicate the ripples with a No. 2 brush and the No. 3 gray. Next, with No. 5 gray and a touch of black, I do the shadow under the wharf, give the stanchions form and texture, and begin rendering some of the boards in drybrush. I also start defining the door and windows, add the rocks, and indicate the rows of shingles with dots.

Step 5. I do the trim on the windows with a No. 1 brush and the No. 1 gray, and their mullions with a No. 4 gray. Next I draw the shingles, expediting the job by doing them with the office pencil instead of paint. With the same pencil, I draw the lines on the loading pylon, the tin sheets on the shack, and the boards on the hull of the beached boat. Finally, with a fanned No. 3 brush and No. 4 gray, I finish the boards on the shack.

DEMONSTRATION 29.

Dirt Road

A dirt road is one of the vestiges of a bygone era that I find irresistible. Of course, it's marvelous to gobble up distances on the turnpikes and get lickety-split to your destination, but, as a result, the fascinating byways that crisscross the country are left unexplored. Just a word of caution to you adventurous spirits about to stray into the unmarked and the unknown—make sure that your tank is full, and that you have stocked up with some goodies in the car to munch on. There are no service stations and no restaurants on country roads traveled only by the milkman or the farmer taking his produce to market. Also be prepared to slacken your pace to 30 and even 20 mph; but the flora, the fauna, and the charm of the road itself should amply compensate for any inconvenience.

I found the road for this sketch on my way to borrow a lobster pot, and though I was pressed for time, I got the Paper King pad and the pencil box and had a go at it. I was lucky I had the Paper King pad in the back seat and pencils in the glove compartment—I'd taken all the materials out of the trunk to make room for the lobster pot.

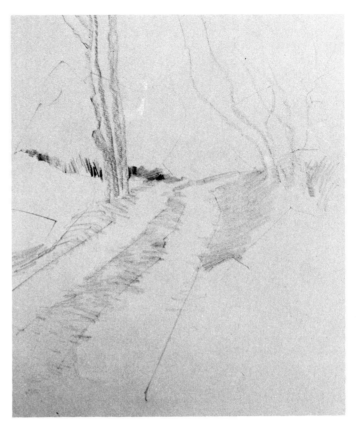

Step 1. I begin here, as I often do, by setting down the bare outline of the big shapes with an office pencil. Guided by my map, I place the trunks of the trees exactly where they belong, using very light pressure on a flat-lead 6B sketching pencil.

Step 2. Here I concentrate on the road itself, working with the side of the lead of an office pencil held under the palm. When I have to press hard to get any dark accents, I place my forefinger right over the lead so it won't break. (I should also remind you that I sharpen pencils with a matknife and bring them to a point on a sandpaper block—a pencil sharpener doesn't give me the long leads I like.)

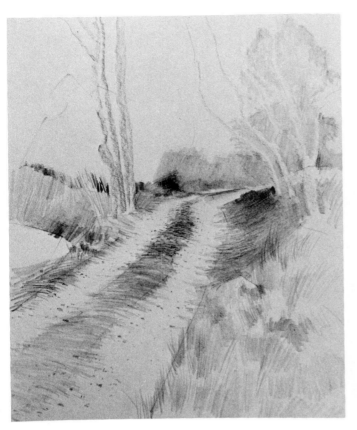 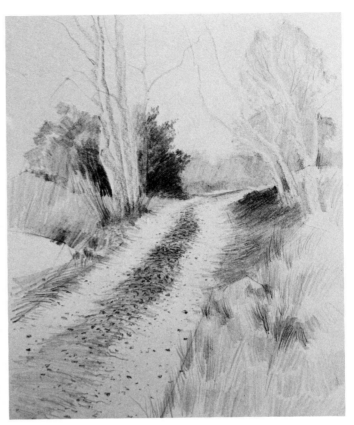

Step 3. I continue with the office pencil, indicating the trees in the distance. Then I move over to the tree on the right, darkening the area around the trunks because I want to leave the trunks themselves in their light value. I press harder to get the darks on the road, as dark as the office pencil allows without doing violence to the paper. I then add the grass and begin the pebbles on the road.

Step 4. Time to switch to a softer pencil—a drafting No. 314. With the side of the lead I do the bark foliage of the trees on the left and then continue sprinkling the pebbles on the road. I also add a few strokes to the grass on the right and at the base of the trees on the left.

Step 5. (Right) I define the tree trunks on the left with the drafting pencil, add the slender branches and twigs, and deepen the tone of the trees behind them. Then I move to the right of the road and define the foliage behind the light trunks. Next I give a few more swipes to the grass on both sides of the road, pronounce the sketch finished, and drive away to fetch my lobster trap.

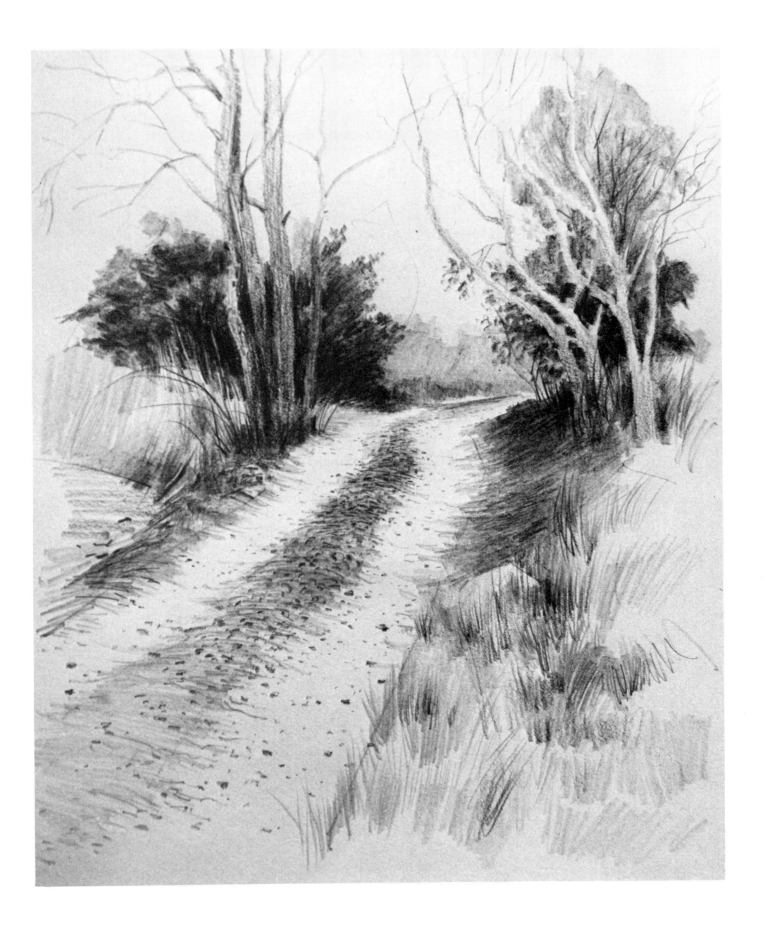

PARTING WORD

Throughout the book I've stressed the point that we must go to Nature and try to capture her charms as we're given the soul to feel, the light to see, and the ability to do. With this as our goal, our mark will still be high, because when aiming at the summit—one doesn't hit the foothills. But I should let the poet have the last word:

> But each for the joy of the working
> And each in his separate star,
> Shall draw the the thing as he sees it,
> For the God of things as they are.
>
> —Kipling

BIBLIOGRAPHY

Ballinger, Harry R. *Painting Landscapes,* 2nd ed., New York: Watson-Guptill, and London: Pitman, 1973.

———. *Painting Sea and Shore.* New York: Watson-Guptill, 1975.

Blake, Wendon. *Complete Guide to Acrylic Painting.* New York: Watson-Guptill, 1975.

———. *Creative Color: A Practical Guide for Oil Painters.* New York: Watson-Guptill, and London: Pitman, 1972.

Carlson, John F. *Carlson's Guide to Landscape Painting.* New York: Dover, and London: Constable, 1958.

Cole, Rex Vicat. *The Artistic Anatomy of Trees.* New York: Dover, and London: Constable, 1965.

De Reyna, Rudy. *Creative Painting from Photographs.* New York: Watson-Guptill, and London: Pitman, 1975.

———. *Magic Realist Painting Techniques.* New York: Watson-Guptill, and London: Pitman, 1973.

———. *Painting in Opaque Watercolor.* New York: Watson-Guptill, 1975.

Pellew, John C. *Oil Painting Outdoors.* New York: Watson-Guptill, 1971.

———. *Painting Maritime Landscapes.* New York: Watson-Guptill, and London: Pitman, 1973.

Pitz, Henry C. *How to Draw Trees.* New York: Watson-Guptill, and London: Pitman, 1972.

Savage, Ernest. *Painting Landscapes in Pastel.* New York: Watson-Guptill, and London: Pitman, 1971.

Vickery, Robert, and Cochrane, Diane. *New Techniques in Egg Tempera.* New York: Watson-Guptill, 1975.

INDEX

Edited by Ellen Zeifer
Designed by Bob Fillie
Composed in 14 point Zenith by Publishers Graphics, Inc.
Printed and bound by Halliday Lithograph Corp., Inc.
Color printed by Toppan Printing Co. (U.S.A.) Ltd.